TEMPLE OF CONFESSIONS

MEXICAN BEASTS AND LIVING SANTOS

"Considered one of the finest performance artists working in the U.S. today, Mexico-born Guillermo Gómez-Peña and his collaborator Roberto Sifuentes have created a surreal, chapel-like environment…viewers become participants, revealing their innermost fears and feelings about Mexicans, Chicanos and Mexican culture….Listening to the [confessions] is like listening to poetry. People are disturbed, confused, ashamed, hopeful."
KATHLEEN VANESIAN, *NEW TIMES*

"[Guillermo Gómez-Peña's] a citizen of everywhere and nowhere, a post-Mexican, neo-Chicano, trans-American. These transitional identities feed the work, become the work….He has become an invaluable voice in the multiculti discussions."
CINDI CARR, *THE VILLAGE VOICE*

"This peripatetic 'post-Mexican romantic' [Guillermo Gómez-Peña] travels around the U.S. and the world practicing a performance art and preaching an intercultural gospel that brings the American melting pot to a boil."
SCOTT CUMMINGS, *AMERICAN THEATER*

"Guillermo Gómez-Peña's award-winning solos combine languages—Spanish, English, Spanglish, Ingleñol, Nahuatl, wild theatrics and guerrilla satire—to convey a new internationalism, a borderless ethos."
JAN BRESLAUER, *L.A. TIMES*

"Cruise with him through a political landscape in which geographic borders have collapsed and language barriers have been disintegrated…this is an America where 'the other' no longer exists."
LAURA JAMISON, *MOTHER JONES*

TEMPLE OF CONFESSIONS

powerHouse Books, New York

MEXICAN BEASTS AND LIVING SANTOS

TEMPLE OF CONFESSIONS

a project by

GUILLERMO GOMEZ-PENA AND ROBERTO SIFUENTES

in collaboration with Norma Medina, Michelle Ceballos,
Carmel Kooros, Zarco Guerrero and Rona Michele

We wish to thank the following individuals and institutions for their support of this project: Nancy Jones, Isabela Basombrío, Paul Smith, Rudy Lauerman, Seth Kirk, Kiersten Armstrong, Jason Dotterer, Valerie Parks, Catherine Lauerman, Larry Baranski, Kay Young, Constance Bruner, Michele Koch, Kevin Johnson, Nathaniel Clover, Louis Gauci, Coco Fusco, Glen Mannisto, and Pamela Marcil at the Detroit Institute of Arts; the Latin American Advisory Board, Founders Junior Council, and the Department of Education of the Detroit Institute of Arts; Michigan Council for Arts and Cultural Affairs; Kim Chan and Cristina King Miranda of the Washington Performing Arts Society; Abel López of the Gala Hispanic Theater; Philip Brookman, David Levy, Paul Roth, Nancy Palmer, Ken Ashton, Steve Brown, Cathy Crane, Sammy Hoi, Jack Cowart, Mary Jo Aagerstoun, Tori Larson, Lisa Ratkus, and Susan Badder of The Corcoran Gallery of Art; Kathy Hotchner, Robert E. Knight, Debra L. Hopkins, Dan Johnson, Craig Nelson, and Carol Holmberg of the Scottsdale Center for the Arts; Lorena Wolffer, Verena Grimm, Janice Alva, Leticia García, Ana Terán, Roberto Vázquez, and Dinorah Bazañes of Ex-Teresa Arte Alternativo, Mexico City; Jeanne Pearlman, Jamie Gruszka, Donna J. Garda, Blake Cook, and Carol Brown of the Three Rivers Arts Festival, Pittsburgh; Olga Juan-Amestoy, Dennis O'Malley, Philip Palombo, Julio Contreras, Rich Weiner, and Harriet Brisson of Rhode Island College; Betto Arcos, Pacifica Radio; Nola Mariano, Anastasia Herold, René Yáñez, Cynthia Wallis, and the staff of the Headlands Center for the Arts.

Para Lorena y Tania, Loretta & Roberto Sifuentes, Doña Martha & Guillermo Emiliano

CONTENTS

THE TEMPLE AS A MIRRO

Wandering in off the street, into the deepest chambers of the museum, seeking inspiration or a chance to rest your imagination, you accidentally stumble upon a couple of homeboys—dressed as new-age shaman and cyber-*cholo*—posing as artists. Would you confess to them your "south-of-the-border" fantasies and actually let them record the words and pictures of your conscience, to be analyzed in the cultural corridors of the Americas, played back repeatedly on National Public Radio, and dispersed on the Internet in the name of art?

Not in a million years....

But a lot of people—angered by the politics of rebellion and immigration or by stereotypes of Mexican culture, burdened by unsettling feelings that our own temples are built upon the burial grounds of others, or intrigued by the prospect of a productive dialogue about U.S.-Mexico relations—have spoken into the microphones of the *Temple of Confessions*.

A confession is the acknowledgment of feeling, an admission of guilt or sin, a statement of religious belief, or the confidential story of experience. The *Temple of Confessions*, an interactive, performance-based exhibition by artists Guillermo Gómez-Peña and Roberto Sifuentes, examines public perceptions of Mexican and Mexican-American culture through exaggerated visual tableaux. Isolated within opposing altars, the artists perform ritual tasks related to Mexican religious and cultural archetypes. They update and exaggerate these traditions by placing pre-Columbian, colonial, and contemporary pop culture icons together in a chapel-like environment. And they invite visitors to participate in their ceremony by contributing, confessing, or thinking about their own relationships to Mexico, stirring existing stereotypes into the cauldron of art.

The *Temple of Confessions* describes cultural differences, fosters an exam-

ination of U.S.-Mexico relations, and posits an understanding of the role played by language in constructing the spiritual and political borders that divide and corral one's thoughts. Asked to create the script of an evolving narrative, viewers become active participants in this ever-changing performance. Its subtext, however, is revolutionary. The *Temple of Confessions* reverses the direction of museum practice and traditional anthropology. The two characters, a *cholo* (street-smart Latino youth) and a futuristic Mexican shaman with a microphone and computer—both traditional subjects of ethnographic study—are themselves collecting information from the audience. By taking up residence within a museum, they are also questioning the museum's role in exhibiting cultural artifacts from other lands. The performers, encased in Plexiglas boxes, signify living ethnographic displays. They satirize the roles that museums play in presenting and representing elements of "exotic" and "other" cultures, inverting the traditional path of dialogue.

The concept of the gallery as "confessional" is defined rather loosely in this project, yet the confessions that are collected are key to its success. The questions become, "What are we confessing?" and "Who are we talking to?" In the Catholicism of Mexico, the confessions of parishioners are supposedly held in the strictest confidence. They form a kind of self-reflexive means of communication with the spiritual. In the *Temple of Confessions*, one's thoughts are recorded and analyzed by the *cholo* and the shaman and then redirected back at the audience. In this way, viewers speak not in a spiritual arena but in a secular or political one. They speak to themselves, looking into a mirror, searching for the complex sources of cultural misunderstanding that are so prevalent in today's discourse. What we find in the mirror is a reflection, an illusion maybe, of our post-modern, end-of-the-century culture, in which the shaman and the *cholo* are stand-ins for us all.

BY NANCY JONES

In October 1994, Guillermo Gómez-Peña and Roberto Sifuentes constructed and performed the *Temple of Confessions* at the Detroit Institute of Arts—within its body, its chambers, its classifying systems. The occupancy, short of duration but with deeply reverberating consequences, was an infiltration of the institutional entity with the substance of new understandings of culture and cultural politics.

The Detroit Institute of Arts (D.I.A.) is among those institutions characterized as "universal survey" art museums, since its collections span continents and millennia. Because of collecting habits that go back to the nineteenth century, the majority of its galleries display the "western tradition," from the ancient Near East westward, through Europe into the U.S. and up to the present. In a courtyard, two stories high, in the museum's geographic center, are the *Detroit Industry* murals. Painted by Mexican artist Diego Rivera in the early 1930s, they embody the Detroit-of-the-past's industrial dream for the future.

These vast murals, this magnificent Mexican presence at the heart of the museum—painted in fresco and infused into the very walls of the edifice—give the D.I.A. unrivaled significance as a pilgrimage site for those who appreciate the complexities of twentieth-century art and politics. They have survived controversy, as in the 1950s when a local eruption of cold-war McCarthyism led to calls for covering them up (Rivera was, after all, a CP member). And they have survived decades of artistic ostracism, residing as they do outside the borders of validity erected by the formalist construction of twentieth-century art history (where realism is out and overt social content is eschewed).

I mention the Rivera Court murals to set a stage. Enter sixty-some years later Gómez-Peña, a cultural voyager born in Mexico's capital,

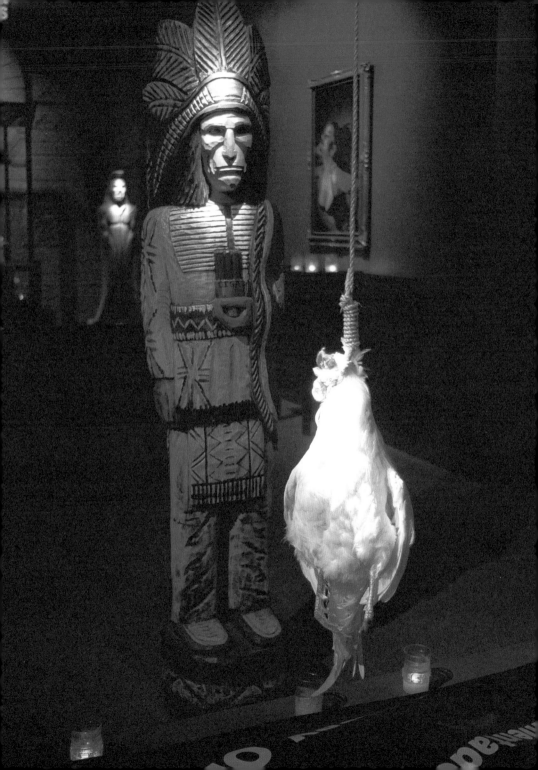

and Sifuentes, a California-bred child of Mexico. Entering to perform the *Temple of Confessions*, a contemporary descendant, in a sense, of Rivera's irrevocable and often problematic presence in Detroit. Like Rivera's murals, the *Temple*, artistically and politically charged, did not enter uncontested into the D.I.A. Rather, in these times when art is politically embattled, it entered over fears—by some—of repercussion.

The *Temple* was isolated in a suite of third-floor galleries, at the top of a long stairway leading up from the back of Rivera Court. Looking up the stairs, a visitor was presented with blacked-out glass doors and a sign above: THE TEMPLE OF CONFESSIONS. Within, burning away at the apex of the museum, the *Temple* reenacted those areas where mysteries are staged—the grottos, shrines and priestly sanctuaries where sacred knowledge resides and is transmitted. Within, Gómez-Peña and Sifuentes performed their knowledge of the cultural crucible that is the Mexico-U.S. border, transmitting it to those who entered.

Just before museum hours began, Guillermo and Roberto entered vitrines encoded—through words in neon, paraphernalia and living creatures (cockroaches, crickets and an iguana)—with messages of fear and desire. The smell of incense filled the *Temple* from altar tables set below temple icons, visions of borderlands hybridity painted on black velvet in faux gilt frames. On the altars the glow and flutter of votive candles surrounded modest statuary—an oversized hamburger bank, Barto (Bart) Sánchez (Simpson) in cheap ceramic, a Day of the Dead sugar skull—all sanctified, made into art through the alchemy of this temple. Centered in the installation, a white taxidermied chicken in a noose hovered, spotlit, above the bulk of a body bag—lettered COURTESY OF THE I.N.S.—a tragic vignette, a memorial to the martyred of *La Raza*.

Over the course of three days Guillermo, seated on a toilet, and Roberto, on a plush red throne, enacted a series of performative rituals, interrupting their liturgical loop to hear us as we confessed. We too became performers, kneeling at the confessional.

No one interrupted the confessions. The faces of visitors showed something I rarely see in the museum—response—emotions coming to the surface—confusion, delight, sadness, fascination, anger—the surface and what lies below coming into consonance.

While the temple of art does not display the likes of paintings on velvet (except as an ironic-chic statement) or popular trinkets from the culture zone of tourist marketplaces, the *Temple of Confessions* brings them in, through the back door, and into a reconstituted space within the halls of sanctified culture. And while the museum has its institutional horror of living critters and bugs—and other reminders of what we would exclude from our cleansed spaces—they live in the *Temple* as part of its theater of representation.

We seem so far away, in Detroit, from the place of the *Temple's* conception. But like Rivera's construction of Detroit industry, the *Temple* transcends the particularities of locale, instructing us to imagine beyond our circumstances. For the collapsed industrial dream is no more ours alone to suffer than is the menace of racism confined to its sites of genesis.

Gómez-Peña has a way of talking about transformation as something that happens over time. It can be situated in the future, engendered by an event in the present borne in memory. One may carry away a troubling thought, a trembling intimation that bears fruit in a day, a month, a year, when resistance in the present has been sufficiently effaced. He is out, it seems to me, to persuade, and is banking on the future.

"Performance, like religion, is about
faith...and deception."
—"San Pocho Aztlaneca" to a journalist

"North American and European visions of Latin
America are fascinating. It is entertaining to
observe the shadows Western thought casts on
the walls of the Mexican equivalent of Plato's
cave. There are two recurrent visions:
Americans and Europeans think they can see
their own alter ego in the Latin American
mirror in the form of a savage but paradisiacal
alternative. What they also see, however,
is radical, Oriental otherness."
—Roger Bartra, "Mexican Reflections on
Distorted Images," *Telos*, 1995

BY GUILLERMO GOMEZ-PENA

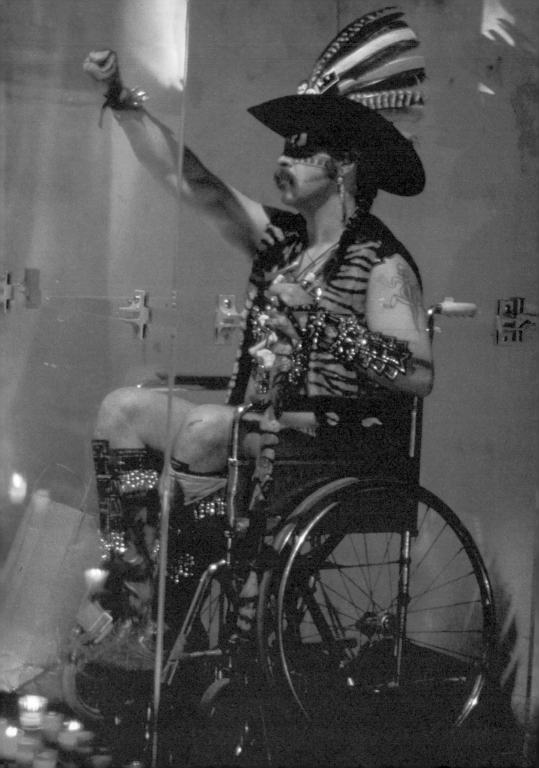

In early 1994, Roberto Sifuentes and I premiered in Arizona our most ambitious collaborative art project to date, a performance/installation titled the *Temple of Confessions*. We combined the format of the pseudo-ethnographic "diorama" (as in my previous "living diorama" projects with Coco Fusco and James Luna[1]) with that of the dramatic religious "dioramas" displayed in Mexican colonial churches, exhibiting ourselves inside Plexiglas boxes as both cultural "specimens" and "holy" creatures.

The piece was based on a religious meta-fiction; we became two living *santos* [saints] from an unknown border religion, in search of sanctuary across America. People were invited to experience this bizarre pagan temple and confess to the saints their intercultural fears and desires. Roberto and I were completely unaware of the Pandora's box we were about to open. Partly due to the profound spiritual and cultural crisis afflicting U.S. society, and partly perhaps due to America's obsession with public and private confession, on opening day people stormed into the Scottsdale Center for the Arts and expressed to our end-of-century *santos* their innermost feelings, fantasies and memories of Mexico, Mexicans, Chicanos, and other people of color. That first performance adventure proved to be quite intense: the gallery experienced record attendance; an angry patron decided to withdraw her support from the institution; and the staff was forced to engage in a healthy debate about the institution's priorities, its mission, and the very role of contemporary art.

For over two years, the *Temple* has been presented in extremely diverse contexts—"high art" museums, experimental art galleries, populist city festivals, university campuses, and a seventeenth-century convent in Mexico City. In every site, the project has been slightly transformed to incorporate some local issues and iconographies. However, most visual and performative elements remain. There are three main spaces: the Chapel of Desires, the Chapel of Fears, and a sort of mortuary chamber in the middle.

In the main altar of the Chapel of Desires, Roberto poses as "El Pre-Columbian Vato," a "holy gangmember." His arms and face are painted with intricate pre-Columbian tattoos, and his tank-top is covered with blood and perforated with holes from gunshots. He shares the restricted space inside the Plexiglas box with fifty cockroaches, a live, four-foot-long iguana, and a small table of useless gadgets—a spray can, a whip, realistic weapons and drug paraphernalia. Behind him stands an "authentic"-looking facade of a "pre-Columbian temple" made out of Styrofoam. As visitors get closer to the tableau, the artificiality (and "in-authenticity") of the image becomes more apparent, and the original shock slowly turns into fascination and uncontrollable curiosity. "El Pre-Colombian Vato" incarnates the fears and desires that Americans feel toward youth of color living dangerously, perceived simultaneously as scary and sexy. Their ephemeral but intensively lived lives become irresistible to a society which has so effectively protected itself from impassioned physical and emotional experiences.

WE INCARNATE
YOUR DESIRES

THE COLUMBIAN

TOBACCO

COURTESY OF

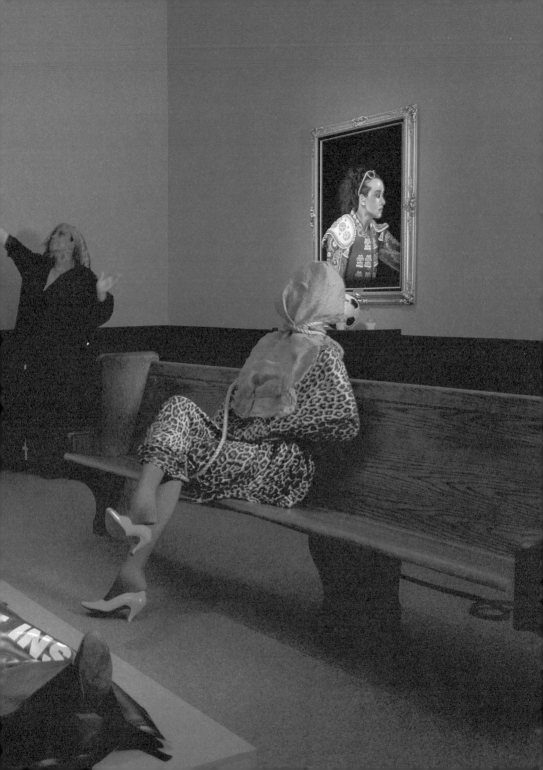

In front of Roberto there is a church kneeler with a microphone for the audience to confess. He never answers back, and rarely does he acknowledge the presence of the confessor (unless s/he is verbally abusive to him).

Opposite from the Chapel of Desires is the altar of the Chapel of Fears, where I sit on a toilet (or a wheelchair) costumed as "San Pocho Aztlaneca," a hyper-exoticized "curio shop shaman for spiritual tourists." I literally wear my composite identity. Dozens of tourist souvenirs and tribal talismans from different parts of the Americas hang from my "Tex-Mex Aztec" outfit.

I share my Plexiglas box with live crickets, taxidermied animals (a rooster and, sometimes, assorted reptiles), tribal musical instruments, and a small table filled with witchcraft-looking artifacts. (In the Anglo imagination, Mexico is frequently associated with pagan rites and pre-industrial wisdom.) A ghetto blaster (which I often manipulate as a musical instrument) plays melancholic music from various parts of the world. An elegant, lavender neon light frames my altar, providing it with a sleek, modern look. The highly technified soundtrack of the entire installation enhances this look even more.

Just as in Roberto's case, from a certain distance, I look "authentic" (I could in fact be an indigenous shaman). But as viewers get closer to my box, their eyes begin to uncover the artifice, and I start to look like a generic Benetton primitive—an ethno-cyborg created by the wizardry of MTV. Despite this, the archetype of the Mexican as wise witch doctor remains intact. I am treated as a special creature, and the visitors attempt to establish a personal "spiritual" connection with me. Their eyes look desperately for mine. If I decide to engage in a personalized relation with them (mainly through eye contact, symbolic hand motions or the mere act of subvocalizing),

emotions begin to pour from both sides: sadness, vulnerability, guilt, anger, tenderness. Some people cry, and in so doing, they make me cry. Some express their sexual desire for me and I discreetly reciprocate. Others spew their hatred, their contempt, and their fear, and I willingly take it. At least a third of the visitors eventually decide to kneel and confess.

In the middle gallery visitors encounter an enigmatic vignette: a six-foot-tall Cigar Shop Indian standing across from a female mannequin wrapped in fake leopard skin, tied with rope. She sits on an old church pew. Both characters seem to be mourning the contents of a body bag stamped by the I.N.S. (Immigration and Naturalization Service), while a taxidermied rooster hangs over the "corpse." Hyper-realistic velvet paintings depicting other hybrid saints—"El Transvestite Pachuco," "Santa Frida de Detroit," "La Yuppy Bullfighter," "La Neo-primitiva," "El Maori Lowrider," etc.—hang on the red and black walls leading to the living *santos*. Beneath each painting there is a small table holding votive candles and a symbolic object—a World Cup soccer ball, a midget Tex-Mex accordion, a plaster Bart Simpson wearing a poncho, etc. These objects change in every site. People are encouraged to light a candle and deposit personal offerings on the tables. We often get photos, charmers, expired credit cards, tampons, condoms, cigars, flowers, and coins.

Two "nuns" (actress Norma Medina and dancer Michelle Ceballos[2]) perform the dual roles of caretakers of the *Temple* and living icons. Norma is dressed as an expectant "*chola*/nun," with two tattooed tears running down her left cheek (one for every murder she committed, according to *pinto* [Chicano prison] culture); and Michelle is costumed provocatively as a "dominatrix/nun" with a lowrider goatee and a garter belt under her habit.

At times, they are mere frozen effigies blending conspicuously with the aestheticized environment. (Their tableaux comment on classical painting, Catholic imagery, porn and movie stereotypes.) They walk around silently, discreetly approaching audience members and encouraging them to confess. They also chant religious songs, and clean the Plexiglas boxes, the body bag, and the shoes of the visitors with their veils. Unexpected encounters with extravagant or sociopathic visitors demand performative reactions which are obviously not scripted.

After two hours of meticulously exploring the *Temple* (the average time people tend to remain in the space), visitors are finally ready to confess. They can confess into the microphones placed on the kneelers in front of the Plexiglas boxes (in which case their voices are recorded, and later altered in post-production to protect their anonymity). If they are shy, they can either write their confessions on cards and deposit them inside an urn, or call an 800 number when they go back home. At night, after the performance, Roberto and I go to a sound studio and listen to all the confessions made that day. The most revealing ones are then edited and incorporated into the installation soundtrack for the coming performances.

By the end of the third day, Roberto and I leave the boxes and are replaced by human-size effigies—a sado-masochistic lowrider with holographic glasses and a "sleepy Mexican" wearing a gas mask and tenderly holding a taxidermied rooster. The performance ends, and the *Temple* remains an installation for the next three weeks. Written and phone confessions are still accepted.

The installation functions simultaneously as an elaborate set design for a theater of mythos and as a melancholic ceremonial space for people to

reflect on their own racist attitudes toward other cultures. And depending on the cultural baggage and racial background of the visitor, and on his/her particular relationship to the symbols and to the performance characters, the space changes its meaning and even its looks. To some it looks like "a Catholic temple from a cyber-punk novel," where they are made to assume the unpleasant role of spiritual tourists. To others, it looks more like "an interactive anthropology museum of the future," where they are placed in the position of cultural voyeurs. People have also defined the *Temple* in written confessions as "a stylized Indian trading post," "an ethnographic porn shop," "a haunted house on acid," and "a post-modern dime museum of Apocalypse culture." This ambiguity is crucial to the work, since it allows for the coexistence of multiple perspectives and reactions.

The kind of recorded and written confessions we obtain through this project, I believe, couldn't possibly be obtained through field work, direct interviews, or talk radio. The extremely seductive yet threatening imagery, as well as the considerable amount of time that people stay in the space, help bring to the surface forbidden or forgotten zones of the psyche. Because of this, the confessions tend to be quite emotional, intimate, and revealing. They belong in the realm of myth, archetypes, dreams, pure sentimentalism, and raw passion. And although some people tend to exaggerate and behave in a performative manner out of insecurity or their

desire to challenge us, most are truly sincere. The range of confessions goes from extreme violence and racism toward Mexicans and other people of color to expressions of incomparable tenderness and solidarity with us or with the cause they perceive we stand for. Some confessions are filled with guilt, some with fear of (cultural, political, or sexual) invasion, violence, rape, and disease. Others are fantasies about wanting to be Mexican or Indian, or vice versa: Mexicans and Latinos suffused in self-hatred, wanting to be Anglo, Spanish or "blond." There are also many explicit descriptions of (real and fictitious, but equally revealing) intercultural sex encounters. And many of these confessions are directed toward us. People invite us to engage in hard-core sexual fantasies or express their desire to hurt us, or even to kill us. Since our job as artists is not to analyze or moralize but merely to open a Pandora's box and let loose the colonial demons, we never express our approval or disapproval to the confessor.

Temple of Confessions is more about America's cultural projections, and its inability to deal with cultural othernesss than about the Latino "other." And in this sense, it is a project of reversed anthropology. Sharing the actual confessions with our readers is perhaps the best way we can contribute to the understanding of the abrupt and dangerous territory of intercultural and interracial relations in contemporary America. We will let the readers reach their own conclusions.

To date the Temple of Confessions *has been presented at the Scottsdale Center for the Arts (Arizona), the Three Rivers Arts Festival (Pittsburgh), the Detroit Institute of Arts, Ex-Teresa Arte Alternativo (Mexico City), the Bannister Art Gallery (Providence, Rhode Island), UCLA (Los Angeles) and The Corcoran Gallery of Art (Washington, D.C.). Under the title of "Chicano Vivant," the Mexico City version was substantially different from the others, since it dealt with Mexico's fears and desires of Chicanos and U.S. Latinos. The Temple will continue to tour throughout 1997 and 1998.*
NOTES:

1. These projects are chronicled in my book *The New World Border* (San Francisco: City Lights, 1996).

2. In Providence, dancer Michelle Ceballos was replaced by Iranian American dancer Carmel Kooros. In Mexico City, there were no nuns.

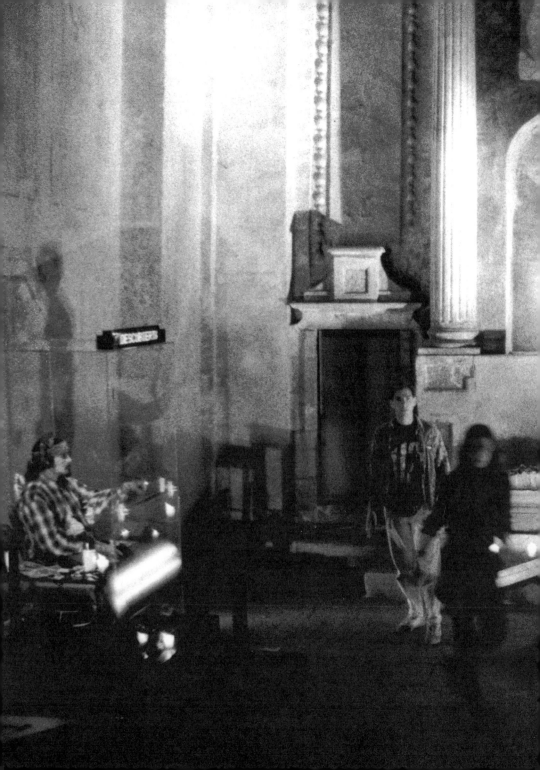

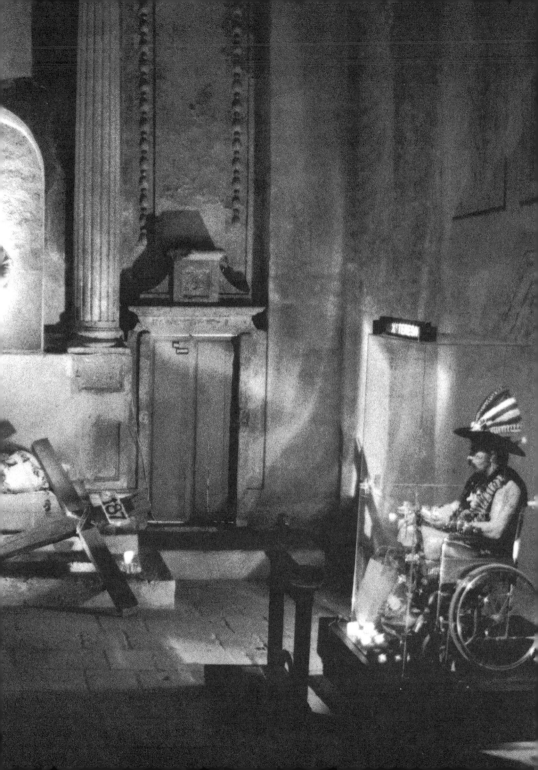

RITO/BLOOD RITUALS

para Lorena

sangre
bienvenida en la memoria
sangre
a través de las décadas
sangre
te lavaste con ella
sangre
me lavaste los pies
sangre
nos lavamos las manos
sangre
morada bajo la piel
sangre
rasguñado por la espalda
sangre
de tanto y tanto besarnos
sangre
que escurre al revés
sangre
imaginaria pero gruesa
sangre
candela en la partida

sangre
en la sala de espinas
sangre
la vida misma
circula en el teléfono
sangre
ojo x ojo/diente de ajo
sangre
nos mandaron a changó
sangre
la bruja se empeñaba en romper el bastón
sangre
sacrificó dos carneros
sangre
pena capital en el tarot
sangre
utilizaste al mismo gallo
que tantas veces apareció en mis escenarios
sangre
nos libraste del maleficio
sangre
con tu puritito amor
sangre
en el performance
a contrapelo
me agarraste por la cintura
y me pegaste un beso de aquellos
sangre
me sangró la boca
sangre
la yugular, la nuca, los nudillos
y luego, de rodillas
sangre
continuamos
sangrando
hasta por los codos
sangre que sangra
hasta el amanecer

BY GUILLERMO GOMEZ-PENA

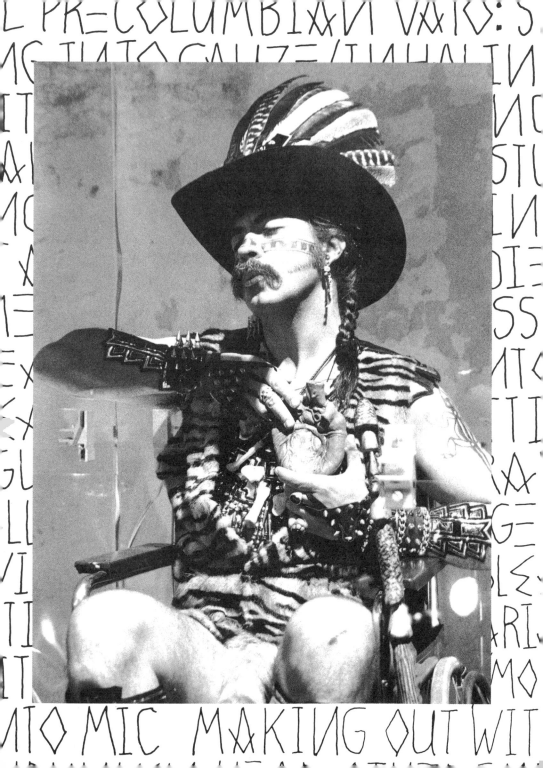

Ritual actions change when "nuns" ring the bell, with song changes, or with an action by the other performer.

EL PRE-COLOMBIAN VATO:

+ spraying into gauze/inhaling paint
+ ritual graffiti writing
+ erotic shaking of spray can/masturbating
+ fondling gun/pointing it at himself and at audience members
+ shooting up into arm, head, heart, tongue
+ patting the iguana (the iguana crawls all over him)
+ self-flagellation with whip
+ "stigmata" tableau
+ marijuana ritual
+ silent scream/mouthing into mic
+ making out with shrunken head

SAN POCHO AZTLANECA:

+ charming snake
+ "chicken pieta" tableau
+ romantic scene with taxidermied chicken
+ *brujeria* ritual
+ drinking blood from rubber heart
+ talking to people while they confess/tonguing mic
+ using ghetto blaster as musical instrument
+ talking to chicken
+ drinking from a candle
+ book ritual (tearing pages)
+ applying make-up
+ "Aztec vampire" vignette
+ playing little toy violin/little Tex-Mex accordion
+ blowing kisses to people/playing with one's tongue in vulgar manner
+ gesturing people to get close
+ combing hair & applying lipstick
+ revealing mariachi bra
+ silent scream into the mic
+ standing up painfully and doing facist salute

NUNS:
- frozen tableaux in different parts of space
 - guiding people into confessing
 - taking care of candles
 - whispering to female mannequin
 - bathing with incense
 - cleaning wooden Indian, pews, Plexiglas, people's shoes
 - praying to the living saints
 - praying to velvet paintings
 - singing Catholic tunes, Indian chants; Arabic throat yodeling
- discreetly weeping next to the body bag and the Indian
- wiping tears off the Indian's face
- using bell to trigger action changes
- Islamic prayer/Catholic prayer
- Holy Water to anoint visitors (those who seem receptive to the act)
- S&M tableau

POSSIBLE SCENARIOS:
- If they don't get it, refer them back to the artists' statement on the wall.
- If they get angry, tell them to please express their anger into the microphone or to write their complaints on a card.
- If they get really angry, send them to a museum representative.
- Dumb or racist questions, answer them in Spanish.
- If psychos or weirdos remain more than two hours in the gallery, politely escort them ou
- Suspicious bags or suitcases left in the gallery, call security.

POSSIBLE QUESTIONS:
Q: Is this some kind of weird Mexican cult?
A: No sir, this is a legitimate religion.
Q: What am I supposed to do?
A: (Instruct them to confess.)
Q: Are these the artists?
A: There are no artists here, only saints. (Or point at the body bag.)
Q: Who is responsible for this offensive shit?
A: You.
Q: Did you kill the chickens for art's sake?
A: No. They committed ritual suicide.
Q: Is that a real body in the bag?
A: Yes.
Q: Who sponsored this offensive exhibit?
A: The American taxpayers, sir.

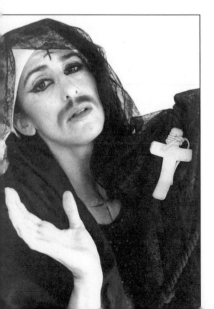

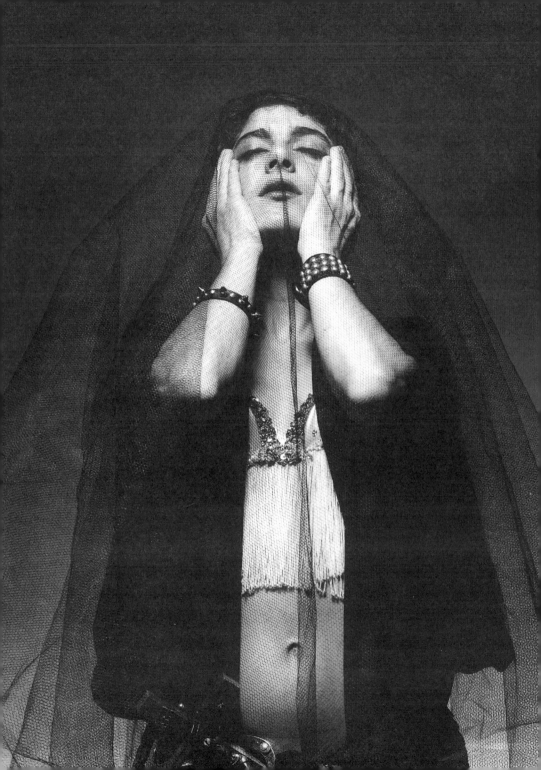

MARCO VINICIO GONZALEZ: What do people want to know about your experience inside the Plexiglas box?

ROBERTO SIFUENTES: We're often asked how people respond to the *Temple of Confessions*: do they believe we are part of an actual religion, do they really want to touch us, hurt us, and how do we feel when people say those incredibly offensive things to us—do we react, get sad, pissed, etc.

MVG: Do you?

RS: Of course we do, but we have to disassociate ourselves from the performance personas as much as we can.

MVG: Have you ever experienced real danger during the show?

RS: We do place ourselves at physical risk in many of our performance pieces. In the *Temple* we confront thousands of people with very provocative images, shielded only by a thin sheet of Plexiglas.

In most American cities where we go, the declining economy and anti-immigrant rhetoric have enflamed feelings of anger toward Latinos. The most insidious and violent experience we ever had was during residency at a college in the Northeast. After only a few days it became clear to us that we were being targeted by reactionary students and skinhead supremacists.

MVG: What happened?

RS: The four of us (Guillermo, myself, and the nuns Norma Medina and Carmel Kooros) were housed on a deserted floor of a old dormitory building that was being remodeled. We were told that we had the entire place to ourselves, and could use it in any manner we liked. So we made ourselves at home. The harassment began soon after.

After our first day we returned to our space and noticed that someone had rummaged through our costumes and props. I can only imagine how our bizarre performance objects

helped fuel their anger and paranoia. Over the next couple of days personal things began to disappear, and one morning Carmel was awakened by two men with crew cuts in our living room, just "hanging out." She told them to leave, and they laughed at her and moved on. We complained to our hosts but they told us that "these things happen on a campus."

The next day things got even stranger. From inside my Plexiglas box, I noticed a gallery visitor watching me with particular interest. He was a large man in his mid-40s—an Anglo-American with a crew cut, dressed conservatively in working-class clothing. He watched me with a strange grin, and came through the crowd right to my Plexiglas box when I started to clean my prop automatic pistol with an American flag bandanna dipped in tequila. He returned every day of the performance, closely watching my every move. After the last day, we reviewed the written confessions. The most aggressive one came from my box, and I immediately made the connection to this man: "Stop cleaning your gun with my flag, you wetback!!"

Later on in the week, we almost came to blows with skinhead resident assistants, moved to a motel at 3:00 A.M., and were given a police escort—without our asking—during the remainder of our stay.

MVG: How have people reacted to your irreverent use of religious iconography?

RS: We approach each venue differently in contextualizing the *Temple*. In Scottsdale, Arizona, we were in the heart of the Southwest, where cross-cultural issues between the U.S. and Mexico are dealt with on a day-to-day basis. But away from the border, in Pittsburgh, it was a very different case. Race relations in that city are largely a black-and-white issue. The Latino presence is practically invisible. So the challenge was to frame the piece in a way that would bring

BY MARCO VINICIO GONZALEZ

in a large and varied audience.

The Three Rivers Arts Festival (in Pittsburgh) is a populist festival featuring pop bands, a craft show, and some performance art. The organizers gave us a clue as to how to anchor the piece when they described Pittsburgh as a very religious, very Catholic city. The immigrant Poles and Hungarians (among others) centered their political and cultural lives around their churches. Despite the value placed on these churches by Pittsburgh's ethnic communities, the conservative bishop had been systematically closing down these de facto cultural centers amid great protest. In order to tap into the religious consciousness of the Pittsburgh audience we created a conceptual press release:

In the spirit of tolerance, religious freedom, and avant-garde art, the Three Rivers Arts Festival will host two high performance priests of an enigmatic, persecuted religion based on confession and "confronting one's intercultural fears and desires."...Banned in the Southwest, it has since relocated, most recently to San Antonio...where unreceptive mono-culturalists and reactionary politicians spouting anti-immigrant rhetoric forced them out of town. After hearing about the religious tolerance of Pittsburgh, they decided to come here.

Our Pittsburgh press release presaged what actually happened. After releasing this statement to the major papers, radio, and TV stations, we were attacked daily on the local conservative "shock jock" and religious hate radio talk shows. The uproar in the right wing community resulted in a huge attendance by conservatives and religious zealots. Some attacked us verbally, others were confused once they arrived, finding themselves moved by the content of the piece, and still others (like the missionaries of old) believed we were an actual "pagan" religion and that we, like most Mexicans, needed to be "saved."

MVG: Tell me about the role of the nuns. What kind of stuff do they do?

RS: For example, Michelle, as the highly erotic, androgynous dominatrix nun, pulled herself silently across the floor with a leash, towards a cowboy—unaware of her movements—as the rest of the crowd looked on. She carefully removed her veil and began to wipe the boots of this guy, transforming the scene from one of self-inflicted S&M torture to one resembling a strange "biblical" scene. The cowboy was so turned on by this action that he chased Michelle with a dollar bill. Michelle, in character, refused to acknowledge his presence and froze in a very defiant tableau. He turned away from Michelle in frustration only to see that the rest of the crowd had gathered around them and witnessed the entire scene.

MVG: What are people's general reaction to the *Temple*?

RS: At each site the *Temple* seems to tap into a part of the local audience's primal curiosity. Some seek us out because they are sexually lonely or spiritually empty; they're literally looking for the "two live Mexicans on display who are ready to listen." Some are looking for a bizarre freak show, or a fringe "pagan religion." Others see us as the incarnation of the marauding Mexican invading their peaceful town/country/language. Whatever their original impulse for seeing the work, most everyone is mesmerized by the images and by the political content of the work, and compelled to stay for long periods of time— even those who hate it. What they reveal about their innermost fantasies and fears—toward Latinos, the Spanish language, immigration and urban violence—and their search for spiritual fulfillment is beginning to take shape as a barometer measuring the climate of racial intolerance in this country. We have only begun to process the volumes of information we have gathered.

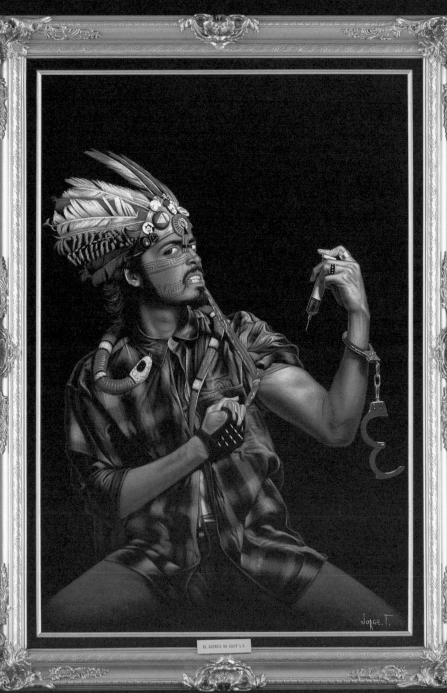

EL AZTECA DE EAST L.A.

JORGE.T.

JORGE. T.

LA NEO-PRIMITIVA

YUPPIE BULLFIGHTER

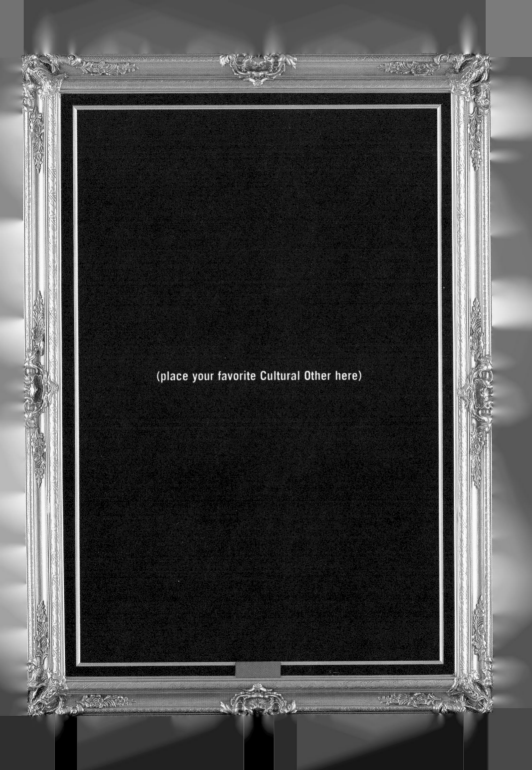

(place your favorite Cultural Other here)

CONFESSIONS

I search out men who are not American. I am American. In many ways I am ashamed of my culture. I am embarrassed by American family values, what little exist.

The following is a selection of written "confessions" obtained during the performance/installation of the Temple of Confessions. *Stylistic peculiarities of each confessor have been retained.*

SCOTTSDALE

"I am a 27 year-old female. My mother and grandmother are Mexican. Each married a white man. I resent them for denying me my Hispanic culture."

"I am a gringo but wish I could someday sing with el Mariachi Vargas."

"I wish one day I could be legal & have lots of sex with blond women."

"I desire badly a Mexican man."

"My desire is that I will get fucked by a Mexican."

"Stop raping the land and seas you ignorant sons of bitches."

"I am an Anglo. My wife is Hispanic. My son is 1/2 and 1/2. Is our family politically correct?"

"To fall in love with a Hispanic & be mistreated."

"I confess that I wish I was able to be as expressive and loving as are the friends I know who are Mexican, Puerto Rican, or South American. I wish for more music and color in the lives of North Americans!"

"I love to fuck hot Nogales whores!"

"I search out men who are not American. I am American. In many ways I am ashamed of my culture. I am embarrassed by American family values, what little exist."

"My oldest sister felt like she didn't want to get involved with a man whose last name was Gonzales. She felt that if her last name was too ethnic that it would cause problems for her, being a female in the field of medicine. She doesn't want to become more of a minority than she already is. I feel I may want to go as far as marrying an Italian, to keep my children's heritage as pure as it can be, because American society has deteriorated to violence and kitsch."

"Two chickens, plucked; two cubes of bouillon (pref. pollo); one small onion; diced cilantro, sal, pimienta—simmer for two hours—three hail Marys—salvation."

INTERCULTURAL

Opposite, Diorama: Iranian mariachi diva and Hollywood norteño

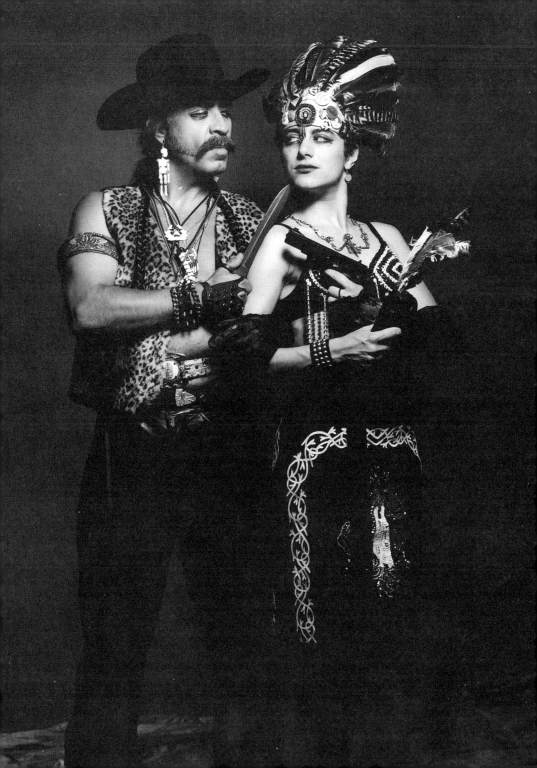

WE INCARNATE
YOUR DESIRES

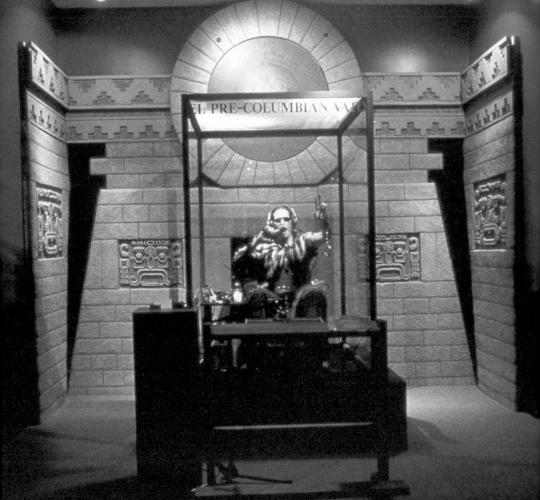

EL PRE-COLUMBIAN VAI

d desire badly

"I want you badly. I think you are sexy."

"I desire freedom from you following me!"

"I wish all Mexicans would be deported!!...And take all this bad art with them!"

"I desire this trash [the exhibit] be destroyed. The drugs, guns, witchcraft stuff and liquor make me think so highly of Hispanics."

"To bash your little head in!"

"The more I look at the mustachioed woman [the dominatrix nun] the better she looks. Nice tits! I desire more bikini-sweet women on the pages of Low-Rider magazine & Charo's jiggily body & Rosie Perez's lips around my penis & my semen squirting into her mouth...More love, more sex, less hate, less violence."

"'Those who restrain their desire, do so only because theirs is weak enough to be restrained.'—Blake, I believe. And yes, I love Mexicans very mucho."

DETROIT

"My father died in 1985. I had never met him. I was 15 when I found out I was half-Mexican. He named me his beneficiary. He worked in the shop. The money from his death and his life bought me a stereo. I wish I had met him."

"I want to be rich and still have an identity."

"I desire to have never been created!"

"I desire to make more pictures with women and blood killing."

"I got here late/anger is coming up for me like an undigested clog of pork blood—purity in blood? I want to sacrifice my anger—blood to purify—more blood."

"To know what would it feel like to kill someone with bare hands. Someone that I've never met, & never get caught."

"I desire a passionate loving Mexican to come into my life and stay there! And to desire me, of course."

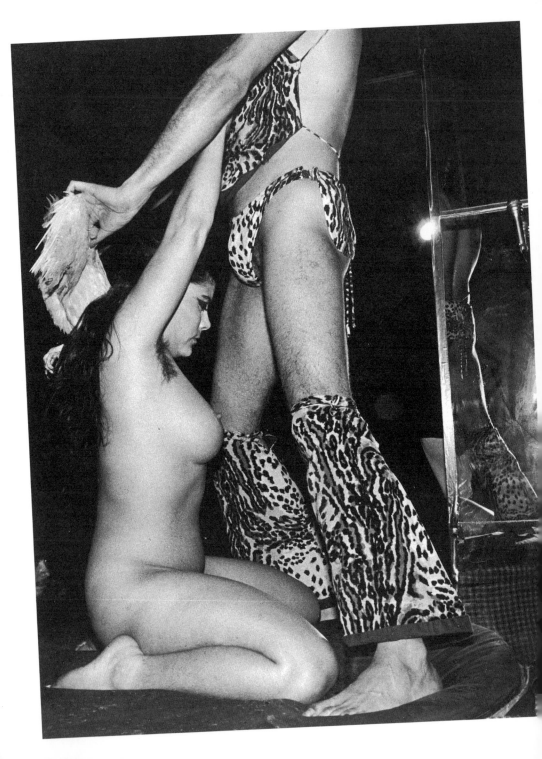

"I desire his touch, his smell, his attention, his gaze. I desire his warmth and unconditional love. I desire his lips, his grip, and his sensitivity. I desire his understanding. I desire his body."

"All that is sweet and dark."

"I badly want a Mexican woman."

"I want to become a woman. A big, robust, black woman with a ghetto accent."

"I have yet to come to terms with my desire for my Mexican lesbian friend. Her kiss on my thigh ended our friendship."

"What I see in this exhibit is an attempt to subterfuge the incarnate desires of envy, jealousy, and misery in a trapped bosom, reflected in the remission of objects [on alter table] we can do without, but sub-consciously, an effect on the mind when we pay attention to it, like TV."

Fear of narrow-minded white Europeans shoving Christianity down the mouths of the Third World

"I desire that freaks like you stay in your little closets."

"You make me want to touch things in a Museum!"

"Freedom from my culturally formed Drug Disease!"

"I wish to stop onanism of the Museé; all this looking and no realization of desire."

"Constructive values for all peoples—recognized and respected differences."

"Open Borders, Life Conscious & Tolerant People."

"That we should drop our reductionist masks of difference and fear."

"I desire for all of us to know & love one another. Thank you."

"I confess to having committed adultery and I wish to be forgiven. This was a sin against my marriage vows, my husband and myself. I am deeply sorry for this and have not repeated the sin. I also confess that I liked it a lot!!"

"I DESIRE THAT OUR BROTHERS OF MEXICAN HERITAGE FIND UNITY AND BROTHERHOOD WITH THE NATIVE AMERICAN BROTHERS AND OUR AFRO-AMERICAN BROTHERS."

"What I feel walking in here is a very confusing thing. It's a fine line between my fears and desires. Quiero ser la misma pero no quiero ser like everybody else. I want to be Mexican, but I don't want to sacrifice my safe suburban white world."

"I wish my father had not married a white woman on purpose to dilute my heritage & make me light skinned…I am now wearing my Abuelo's shirt. He died never hear-

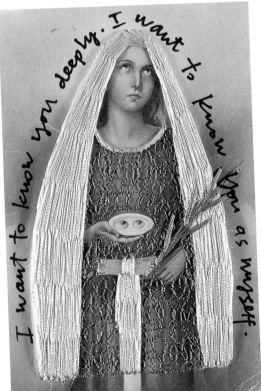

ing me speak español. He died & took his stories with him. I hope your Abuela gets well soon. I have a feeling you know her stories."

"I desire to be loved by a Mexican Man who will not love me because I am not Mexican."

"What happened to Aztlán? Qué paso? Why has our land atrophied?"

"Yo quiero a un Revolucionario! Yo Necesito una Revolución! Nosotros necesitamos un Revolución aqui en el Norte. Libertad de la opresión de la gente de Los Estados Unidos. Soy un anglo, pero conozco la verdad."

"I want to be seen as a true advocate of your culture; as righteous and not as a 'white liberal' & to make love to a Latina with a firm body."

I ALWAYS LUSTED FOR CASSANDRA LOZANO. BUT I BIT MY TONGUE.

"I want to know you deeply. I want to know you as myself!"

"I desire to meet you, but it's enough that our minds are running in the same channels… So my desire will have to be to meet my soulmate. Please, set it up for me!"

"You Mexicans—Don't kill the Wild Deers anymore. Please! Also don't shear the sheep!"

"Health, money, happiness, and especially, expatriation."

"I desire to achieve your ultimate goal, & with God's help nothing can get in the way, so you can travel on the bus all the way through to your desire."

"To be special and the trouble it brings."

"Justice & Revenge!"

"I desire what I fear!"

PITTSBURGH

"A large uncut hispanic cock!"

"My brother George hates white people. He's half white."

"To see the iguana go to the bathroom."

"I desire to live in a place where labels of difference and identity (white, Mexican, Catholic, Agnostic, etc.) are overlooked and similarities are stressed."

"I always lusted for Cassandra Lozano. But I bit my tongue."

"I was very close with a young Latino man. He was the most warm and open person I have ever met. He opened me up in so many ways."

I fear that America will be

"Why has democracy been so difficult to establish in Latin America?"

"What is the meaning of your culture 'cause I'm scared of it."

"I have always desired leaving this earth and have tried many ways including drugs—to get high, to numb out. I do not believe that your culture is unique in that you have also found ways to leave."

"I have to say that this [performance/installation] is very interesting because the man that I desire most is a Latino...from Chile, whose work deals with the border zone between the two cultures with which he is involved. I love this man—I call him a godman (a man who is like a god who walks on this earth). All other men hate that phrase. I find that intimidation amusing. I feel that the things that make me love this man above almost all others (he doesn't love me) derive from his Latin background—beauty, passion, intelligence, love of women, manners, sex—I will always worship Latin men because of my experience of him."

"I don't understand why Catholicism is so widely embraced in Mexico. If I were from Mexico I think I would be very resentful of Catholicism."

"My skin is very white & smooth & soft. And all I can do is worship you. I love this piece. I love your bleeding heart. I feel these images are beyond culture, but I promise to consider our cultural differences in a more sincere way. I think you are so beautiful, stimulating my desire, incorporating my fears which are a part of that desire. I wish I could talk all day to you. I wish my hair and my body were nicer. I wish that I was more beautiful for you & my thoughts more interesting to better speak to your work."

"I feel all Mexican women are whores."

"My first exposure to Mexican culture was Mexican jumping beans. They were little plastic eggs with toy weighted balls inside. We had a Mexican family on our street (the Perez's). They had lots of kids. They ate a lot. I remember the good food smells coming from their house. They kept chickens at home. It was great!"

ne a two-language country.

"Peyote, mucho peyote. Y que la violencia sea pan de todos."

"When will we begin to feel safe again? No more violence, no more guns! Wanna be safe once more. Please stop the hitting, the shootings! Please stop the hate. Please stop the hurting. I wanna be safe!"

"I want to burn this city [Pittsburgh] out to a shell and let weeds cover the asphalt; let rain fill the basements; beat up granny for a fucking quilt and eat chicken bones for breakfast."

"I desire to live in a splendor of pleasure. I desire to cleanse the world of spiritual sickness. Christian science is living off the blood of my asshole and I'm tired of all the shit fuck this planet. I want to speak my own fucking language; write my own history and die in my mother's garden."

"And those who are Christ's have crucified the flesh and its passions and desires. If we live in the Spirit, let us also walk in the Spirit...But if the fruit of the Spirit is love, joy, peace, patience, kindness, gentleness, goodness and self control; against there is no law. (Galatians 5:24-25)"

INTERCULTURAL

QUIERO SER LA MISMA PERO NO
QUIERO SER LIKE EVERYBODY ELSE
I WANT TO BE MEXICAN, BUT I
DON'T WANT TO SACRIFICE my
SAFE, SUBURBAN WHITE WORLD.

SCOTTSDALE

"I don't have any fears about Mexico. I would like to travel there and eat at the cafes and see Incan Ruins and shit."

"I fear ignorance on the part of all cultures. Because, ignorance results in death, war, stolen land; death to innocent children, innocent mestizos, innocent gringos…"

"(I fear) that you may get hemmorhoids (for sitting on a toilet for 8 hours), and that your black magic and potions will make them worse."

"I am all for cultural diversity as long as it doesn't raise taxes."

"I am concerned over the many peoples from Mexico coming across the borders illegally. How do we assimilate all these people without a heavy burden on our resources?"

"I fear that America will become a two-language country. My parents were immigrants but they learned English. Can't you Mexicans do the same?"

"I feel some self-loathing at being white, a U.S. citizen of Euro background. Ashamed of my history, my skin. And when I am in Central America, I feel so conspicuously oppressive."

Opposite, "Border Cali"

"I truly fear Montezuma's Revenge."

"My fear is that South of the border is North of someone else's South, wherever you are. Amen."

"'There will be 100 Wal-Marts in Mexico by this time next year'—news item."

"Fear of narrow-minded white Europeans shoving Christianity down the mouths of the Third World."

"That indigenous people of the world will not survive."

"Why the voodoo in your work? Many things in your culture scare people visually. Can't you be more positive, more sensitive towards us?"

"Not understanding MACHISMO, nor my attraction to it…"

"My worst fear is…black velvet paintings…especially in a serious museum."

"I wish I could speak to you but I will cry. I don't want to cry. I feel sadness, anger, pain, fear. I feel strongly connected to something in this room. Perhaps it's the sadness."

"I fear your DEEP STARE."

"I certainly fear [the pregnant nun] standing next to me."

"Lutherans have ritual on their skin like cum. I wash myself, but don't want to."

"I fear not being seen, noticed, or liked like you guys are. It must be an interesting way to watch people watching you. Usually people wouldn't have the guts to stare at you and you back at them unless being inside the glass."

"I fear too many chickens abused for art's sake."

"I am scared shitless of women from other cultures talking to me."

"Lo puro, lo único, lo sólido."

"I hate you precisely because I understand you."

"To speak into a mic and say the truth about anything."

"Fear of fear; fear of anxiety; fear of paranoia. I am full of fears, man."

"I fear Mexicans because of the way they look at me, sexually."

"I hate Mexicans. All they are is babymakers."

"I fear Mexicans getting medical services and Americans having to wait."

"A mí me parece que las pinturas y los símbolos de la exhibición evocan stereotipicos de la raza. Sus pinturos son buenas pero son para anglos."

"When I see a Mexican or a Mexican-American man, I cringe because I assume he's going to make a sexual comment to me."

"I am afraid of Mexicans when I am walking at night because they are the only ones that drive by and whistle."

"When I was young I feared Mexicans!! Not until I visited the Mayan ruins in Tikal, did I come to understand the depth of the Mexican/Mayan culture."

"I fear bull fights; the children who must watch the bull fights; the lives of the many unwanted children and people."

"Arizona becoming like Santa Ana, California."

"My sister works for the INS. I wish she could come see this installation. But she won't. She likes her job & she's chicana. Mother crossed the border 30 years ago."

"Not knowing the language makes me afraid—of them—what might happen if I could not be heard."

"You people treat your women like slaves and your pets like shit."

"Afraid of 'the Bloods.' They are my natural enemy."

"Mexico is not a fear, it is a culture, sublime beauty. White Americans simply don't understand."

"It has been my impression that Mexican men have the power and the women are less than 2nd-class citizens. True or false?"

"I have a confession to make: we fucked the Mexicans up and if I could change the past I would."

"I fear 'South of the Border'...of your mind."

"I'm half white (German/Jew) and half Mexican. My girlfriend is white but her ancestors are from Ecuador. Does that make me white?"

"I am afraid of spicks; and beaners."

"When I think of Mexico, I fear that I have to eat a roach."

"I believe that a large part of this people's history [the Mexicans] is contained in the Book of Mormon. They were strong tribes who chose either to accept Christ or not to. They were taught that if they lived righteously, they would keep their promised land. However, they continued in war and wickedness, greed and violence, and they became unable to maintain all the Lord had given them."

PITTSBURGH

"Fear of being intimidated by art."

"I fear any group or culture or people that seek or attempts to impose personal beliefs (i.e. judgements) on other peoples."

"(I fear) Here & now."

"Proverbs 1:7: The fear of the Lord is the beginning of knowledge, but fools despise wisdom and instruction."

"Sorry, but I know no racial boundaries."

"A bunch of 'C__P' I resent my tax money going for such trash."

"You Bigots!"

"Fuckhead!"

"I fear that I will look god awful white."

"I fear that too many people will take this exhibition negatively, even though it's meant to reflect the cultural and actual feelings of the Latin people and the way they are treated in the United States!"

"That I will get raped by..."

"Coming from the misunderstanding of culture, the soul, my soul, is lost between myth and belief."

Transcribed by Anastasia Herold and Zarina Rico

The following is a selection of verbal "confessions" recorded live during the performance/installation of the Temple of Confessions *and placed over a toll-free number advertised in local newspapers.*

"A country of wonderful potential, I do know that—and it hasn't yet been fully developed, but I think we are going to see some wonderful things from south of the border...I really do."

"I want to confess all my sins, all of my terrible sins...of wanting to be like the conquistadores...For so long I tried to blend in; I wanted to forget mis raízes, I wanted to forget that I was India, I wanted to be just like Las Gringas. And now I feel like I have to be me again, I have to be myself again; La Latina, La Latinoamericana, de nuevo...."

I fear that in of the world

"I've spent time in Mexico. I've been in the interior. I'm a photographer. I've enjoyed the Mexican people, the Indio. I think the government is very cruel. I think the peoples of Mexico probably have as their worst enemy the government, the intelligencia, the class system. When I was in Mexico I was working for a company and a man who hated the Indians—and I used to tell him, 'Gonzalo, Indios are good.' And I couldn't believe that there was so much cruelty and indifference...and every time I tried to help or give money to an Indio, because they were starving, my client would be very angry....I had to decide whether I was going to please my client or please myself. There's a part of Mexico that scares me, because there's a lot of cruelty. It's also primitive, beautiful. I think the people are probably more beautiful than the plastic world in the U.S. that we have. I think they are closer to the land. I think they're closer to what life is, relationships, etc. Salinas is probably the best of all the presidents that Mexico has had, since the turn of the century

probably. But the political corruption in the system is so corrupt I don't know if it will ever be alright."

"Do you speak English? No español? Mexico's like pretty cool, 'cause you can get like firecrackers there. And it has no laws—it's cool! They have cool customs there. And like the cops, they have like shotguns and stuff, and they're like really mean and stuff, and like you can buy beer and stuff. It's like really cheap and stuff….that's like it."

"I was living in a house where one of the commissioners of the border patrol lived. He explained to me the unimportance of political correctness. He explained to me 'wetbacks know they're wetbacks.' I turned to him and said nothing for he was letting me live in his home. He was feeding me and he was giving me a place to stay. And I thought to myself, does that mean that kikes know they're kikes, wops

li genous people vill not survive

know they're wops? It was very disturbing to me. But at the same time I couldn't find myself to lose respect for him, for he was feeding me and giving me a place to stay.…It was quite disturbing."

"I'm sorry for feeling ashamed at times for being Mexican or Hispanic or whatever everybody calls us."

"You know everything they say about Mexicans, I believe it."

"Soy un indio que quiere asasinato los blancos y todos no vale nade mentiendes? No hablo español muy bien pero, yo soy indio. Por que no?"

"Some of the stereotypes that I have: like one that always strikes me is one of poverty, of Mexican poverty, and I guess that's not always the way it is; I just don't know…I think maybe of uncleanliness, of being dirty."

"What happens to the Mexican people when they die? I'm just curious. I'm Christian and I believe that Jesus Christ came to save me and I will go to heaven and I'm just wondering what significance that has; do the Mexicans believe that? I feel sadness because they don't know the true meaning of this; they're lost in their traditions because they don't know what happens when they die—they don't know Jesus is their true savior and that's what makes me sad; that they have to pray to these gods and goddesses of the earth. Do most Mexicans participate in this what-ever you call it—this ritual? It reminds me of Satanism. Satanism! I'm not really scared just…I don't know…maybe because it's foreign to what I know of religions."

"You have a home you should be proud of and I do not see why you need to put pretty lights around it and try to sell it to people for art. Why are you doing this? You're bringing idols of voodoo and black velvet paintings. Personally, I'm very impressed by the art but it's creating a pop culture from a very poor lifestyle in a very proud country. I wish you could travel and I hope you find something to truly be proud of. Amen."

"Actually I think I'm quite normal; I masturbate everyday because I'm afraid to tell my lover he doesn't know what he's doing. I become real friendly to other races because I'm afraid that they'll know that I can't stand them and I became a vegetarian because I was afraid that I wouldn't be in with the trend so actually I think I'm quite normal."

"Midwest Chicano wants to confess I loved the performance last night
gave us some laughs and shed some light, on this dark land of reactionary blight
Wilson's a good partner for Engler, who plays with our lives like a riverboat gambler
claims he's hard and yet he's big but like—he's a pig
I love the chickens like any good Mexican
got me thinkin' about the god damn pot lickin' boiled chicken white
bred-eatin' tap feedin' Gabatchos, Werkos, (Volios), Gringos,
Gatchipos damn, tryin' to tell me who I am
want to be what's good for me what's good for me…What's good for me
certainly not being Hispanic going through all the antics being
white actin' bright, I do me bright they said I should fight
fight of the Christian bring us false religion
monolingual freaks sneakin' at night stayin' out of sight
stab us in the back—black darkness of light…Love you guys
you made my spirits rise performance was a winner and I still
want to prepare you a great midwestern Mexican dinner."

USA 29

Mar 11, 94

APS CEO DeMichele

Gentlemen,

We were appalled by your Old Mexico exhibit at Scotts Center for the Arts.

The dead chicken & the horizontal (hanging by its neck) 1-legged man-like figure upstairs were disgusting. The books with nails & the devil worship, voo doo, etc seemed so awful in a world with so many problems already. I think we need to get back to God, religion & good common sense and not eppose our young people to unnecessary trash.

I hope you are able to do something about this.

Yours truly,
Mrs J R Mulligan

John E. Reed
HOLLYWOOD

The following phrases were collected by the artists from different sources: the media, vox populi, people in the streets, conversations with well-meaning and not-so-well-meaning racists, etc. Some of these phrases were incorporated into the soundtrack found on the Temple of Confessions Audio CD.

ON FEELING OVERWHELMED BY IMMIGRANTS

"It's not like it used to be. These meskins are everywhere."

"I feel like a minority in my own country."

"Since they came to town, you just can't leave the door open no more."

ON LAW ENFORCEMENT

"Let's go for some mexercise." (LAPD)

"Aliens are fun...to catch." (Border Patrolman)

"If you catch 'em, skin 'em & fry 'em yourself." (Harold Ezell)

ON LANGUAGE

"We don't speak Mexican here." (Sign on a storefront)

"I speak a little Mexican, you know, enchilada, yi-ha, yi-ha, cucarrracha."

"Your Spanish is Castilian, right? It's not like Mexican Spanish. You know, chin'gda, pinchi gringou cabroun and all that stuff...."

ON DISTINCTIVE IDIOSYNCRASIES

"Mexicans love to rip you off. It's like their national sport."

"It's like, they are always waiting for a tip."

"They love to bargain down there. And they get pissed if you don't."

"They want everything for free. They think they are still in Mexico."

"Just like the Indians, they can't handle alcohol."

"It's sad. Like the blacks, they are always fighting for crumbs."

"When a Mexican is not sleeping, he's probably drinking."

"Mexicans don't really want to prosper."

"They can't handle positions of power."

"Mexicans can't handle technology."

"Mexicans don't fear death. I mean, they don't mind dying. It's a religious thing."

"I have nothing against Mexicans. They are harmless. The real violent ones are the Chicanos."

"Mexicans have an inferiority complex."

Opposite, "The Mexican Hat Girl," image found at a Texan flea market. 65

"They are not uppity
like the blacks."

"You never know what the
wets are really thinking."

"Their sense of time is
different, Mexican time,
you know."

ON MEXICO

"The only problem with
Mexico is the Mexicans."

"They don't work as much
down there. They take
siestas, three times a day."

"All the politicians are corrupt."

"I heard that in Mexico there's
not enough schools. The
government wants to
keep 'em ignorant."

"The telephones don't really work."

"They don't respect the most basic
environmental standards."

"They are into child labor and shit. It's real horrible."

"Never bring your watch to TJ."

"They'll steal your hubcaps and sell them back to you."

"If you get pulled over, don't worry, they all take bribes."

"Never count your money in the open down there."

"That's a Mexican coin, not a real coin."

"Peso little/eat so grandi." (1950s billboard)

"Do they have universities down there?"

"Who made those pyramids. Aliens? I mean
from outer-space?"

"The faxes are made out of wood. And they use
tortillas instead of paper. Ja-ja!"

"They are simple people. They are happy with the little they have."

"They are not ambitious and complex like us. Sometimes I just feel like going down there and living among them."

"I'm going to Mexico next week. I got too many problems. I need some fun and relaxation."

"They are real nice. When you meet them, they give you everything they have. It's the blond hair, like we are gods or something."

"Just give 'em a couple bucks and they'll take you anywhere."

ON FOOD

"Mexican diet is horrible, man. All that grease, picanti and cholesterol."

"Sorry, I don't eat Mexican food. I'm into healthy stuff."

"Do you got burritos without lard?"

"Can I have a carni asada burrito but without meat?"

"Watch out for Montezuma's Revenge."

ON IDENTITY & MEDIA STEREOTYPES

"…you're Julio Iglesias…No, Jimi Smits, right?"

"Hey Ricky! How's Lucy?"

"Babaluuuu!…"

"You look like…Carlos Santana."

"Hey! Carlos Castaneda!"

"Cheech and Chong!"

"Please leave the chickens home."

"Ey Cisco, where are your pistols?"

ON ART

"I love Mexican art. It's great kitsch."

"I go down there to buy little things for my altars."

"They are not into experimentation. Their real strength is surrealism."

67

"Everybody is an artist down there. They work real good with their hands."

"They perform for a lot less money."

"I have yet to find a Mexican conceptual artist."

"It's like, they're stuck in tradition."

ON MACHISMO & SEX

"The men are mucho macho."

"Mexicans have little weenies, chiquita perro picanti."

"Their dicks aren't as long as the blacks', but they are real wide and super hard."

"They are real homophobic."

"Some Mexicans are cute, but they follow you like dogs."

"They look at you like they just want to fuck you."

"You walk by a group of Mexicans, and they just scream at you, 'Mamacita, ven
 aqui, guerrita, nice chichis.' They are so...It's part of their culture. I'm sure
 Mexican women are used to it."

"They just can't differentiate between friendship and sex."

"I love Mexico. Down there I'm beautiful just because I'm blond."

"I lost my virginity in Acapulco, to a waiter; he treated me like an Aztec Princess,
 but it didn't last, you know. All he wanted was a green card. He now lives in
 Downey with a fuckin' Chicana."

"Mexican men always abandon their wives."

"They are obsessed with their mothers."

"You know, the madonna/whore complex."

ON THE "SEÑORITA"

"Those señoritas are always horny."

"They are sweet and quiet. They love to be dominated. They are not like the
 feminists here."

"Once you marry them and give 'em three kids, they don't mind you
 fucking around."

"They just can't stop having babies. If only they were better educated."

"They sleep & fuck & sleep & fuck & have babies. They're Catholic.
 They don't believe in birth control."

"The women get pregnant and then come over here to have their babies so they can
 become citizens and go on welfare."

ON A PERSONAL LEVEL

"You are not like them. I mean…you're…different. You're educated…here."

"Where did you learn your English? It's pretty good."

"You are extremely articulate.…I mean for a…"

"Were you an affirmative action baby?"

"It's like you guys get all the grants & shit."

"You probably taught all those guera art administrators to dance salsa, right?"

ON POSITIVE FAMILY AND CULTURAL VALUES

"You're so lucky you are Catholic. I have to pay my therapist $200 a week."

"It's so foreign to me; your family is huge and you are all so close. It's like
 a little community."

"You guys have this weird oedipal complex with your mothers."

"You mean you get along with your parents?"

"Wouldn't your grandmother be happier in a rest home? Isn't she bored at home?
 Aren't you tired of her?"

ON HUMOR

"So what is a Mexican?
 The proof that Indians fucked buffaloes."

"What do you call a Chicano baptism?
 A bean dip."

"How do you say Rodney King's name in Spanish?
 Piñata."

"What do you call a black man in court?
 Guilty."

"How can you tell when Dominicans have moved into your neighborhood?
 The Cubans get car insurance."

"What do you get when you cross a Puerto Rican and a Chinaman?
 A car thief who can't drive."

"What do you say to a Chicano in three-piece suit?
 'Will the defendant please rise.'"

Jokes excerpted from René Yáñez's "The Taco Bell drive thru University Humor Survey."

CHORUS:

ROSA, ROSA LOPEZ
ROSA SALVATRUCHA
ROSA ROSA MORENA
ROSA ROSA VERGONA

Without you, the only Latino
at the Trial of the Century
would've been a voiceless bailiff!
But no, you took center stage,
¡la salvatrucha más famosa en la historia
de este país mierda, pues!

Yeah, you and Pete Wilson's maid!
You and Arianna Huffington's maid!
You and Dianne Feinstein's maid!
You and thousands of criadas and housekeepers,
jardineros and day laborers,
meseros and fruitpickers!

You're the ultimate subversive, Rosa:
dressing down in your moth-eaten jumpsuit
to make Marcia Clark look like the petty yuppie she is:
she and her $200 haircuts and pin-striped suits!
(¡por favor!)

Ah, but it is all about money, ¿verdá que sí, Rosa?
They accused you of lying for the cash.
(¡Qué difamación!)
Let's suppose that you did
(though of course you didn't!)
But supposing you did?
¿¿¿Y qué??? ¿¿¿Y QUE??? So what!
Isn't everyone out for a buck in this case?
You were just out for your piece of that pie.

(CHORUS)

You go on, girl!
¡Claro que sí señor!

BY RUBEN MARTINEZ *Text from musicalized spoken word piece produced*

After all those years washing the clothes
¡los calcetines!
The socks! the socks, the bloody socks!
The years of meals the years of mopping the years
of dusting the years of walking the dog (¡perro mugroso!),
years of smiling and saying sí, señor, sí, señor, sí señor...

¡NO SENOR!

(CHORUS)

Return to the land that drove you out
land of black sand and golden palms
return to the land that saw your birth
land where you cleaned your first house
la patria te llama, Rosa
te llama tu patria en llamas
your land calls to you
your land in flames

So you take that stand!
You snap back at Chris Darden and put him in his place!
You smile at Meeester Jah-nee!
Dale, rosa salvatrucha,
que trucha eres
dale duro, duro, duro
dale con tus siglos de coraje
dale con tu ironía sublime

Too bad your salvatrucha irony doesn't come through
the mousy voice of that translator:

Pero tú, Rosa López,
Rosa-alvatrucha,
Rosa morena,
Rosa vergona:
your dignity needs no translation...

And you returned to your ranchito querido in El Salvador
paid off with only a blue dress and black heels

ollaboration with Johnette Napolitano and East L.A. rock gods Los Illegals

THE BATHROOM IS HERE
EL BANO ESTA AQUI
el BAHN-yo ess-TA ah-KEE

PARK HERE
ESTACIONATE AQUI
estah-see-OW-nah-tay ah-KEE

KEEP THE GATES (DOORS) CLOSED
MANTEN CERRADAS LAS PUERTAS
man-TAIN sair-RA-das lahs PWAIR-tas

DON'T LET THE DOG OUT
NO DEJE SALIR AL PERRO
no DAY-hah sa-LEER al PAIR-ro

USE THIS ROOM
USA ESTE CUARTO
oo-SA ES-tay KWAR-toh

21

MOVE <u>THE BOARDS</u> TO HERE
MUEVA <u>LAS TABLAS</u> AQUI
MWAY-va <u>las TA-blas</u> ah-KEE

MUEVA _____ AQUI

LUMBER	*LA MADERA*	la ma-DAY-ra
PILE	*EL MONTON*	moan-TONE
TRASH	*LOS BASURA*	ba-SOO-ra

BRING ME <u>THE SHINGLES</u>
TRAIGAME <u>LAS RIPIAS</u>
try-ga-may <u>las REE-pay-ahs</u>

TRAIGAME _____.

BOARDS	*LAS TABLAS*	TA-blas
DRILL	*EL TALADRO*	ta-LA-dro
PIECES	*LOS PEDAZOS*	ped-DA-sohs
NAIL GUN	*LA PISTOLA*	pee-STO-lah
SAW	*EL SERRUCHO*	ser-ROO-cho

17

PAY

I'LL PAY YOU ____ DOLLARS PER HOUR
TE PAGO ____ DOLARES CADA HORA
tay PA-go ____ doh-LAR-es KA-da OR-a

I'LL PAY YOU ON FRIDAY
YO TE PAGO EL VIERNES
yo tay PA-go el VYAIR-ness

LEAVE ME THE BILL
DEHAYME LA CUENTA
DAY-ha-may la KWEN-ta

SCHEDULE

WHEN CAN YOU WORK?
CUANDO PUEDES TRABAJAR?
KWAN-do poo-AYDAYS tra-ba-HAR

START WORK AT NINE
EMPIEZA TRABAJAR A LAS NUEVE
empee-AY-sa ah traba-HAR ah lahs NEW-ay-vay

STOP WORK AT FIVE
TERMINE DE TRABAJAR A LAS CINCO
TAIR-meena day traba-HAR ah lahs SEEN-ko

TAKE A BREAK
DESCANSA TE
des-KAHN-sah tay

QUITTING TIME
HORA DE TERMINAR
OR-a day tair-me-NAR

LUNCH
LONCHE (slang)
LOAN-chay

PICK UP THE TRASH
RECOGA TODA LA BASURA
ray-CO-ha TOH-da la ba-SOO-ra

RECOGA TODOS ____.

NAILS	*LOS CLAVOS*	**CLA-vohs**
PIECES	*LOS PEDAZOS*	**pay-DA-sohs**

REMOVE THE SHINGLES
QUITA LAS RIPIAS
KEE-ta lahs REE-pay-ahs

QUITA ____.

PAINT	*LA PINTURA*	**peen-TOO-ra**

TILES	**WALL PAPER**
LOS AZULEJOS	*EL PAPELTAPIZ*
los ahsoo-LAY-hohs	el pa-PEL tah-PEES

PUT THE SCREWS HERE
PONGA LOS TORNILLOS AQUI
PON-ga lohs tor-NEE-yohs ah-KEE

PONGA ____ AQUI

THINGS	*LAS COSAS*	**CO-sahs**
LUMBER	*LA MADERA*	**ma-DAY-ra**
NAILS	*LOS CLAVOS*	**KLA-vohs**

PUT THAT IN THE HOUSE
PONGA ESO EN LA CASA
PON-ga ES-so en la CA-sa

PONGA ESO EN ____.

BAG	*LA BOLSA*	**BOL-sa**
GARAGE	*EL GARAJE*	**ga-RA-hay**
TRUCK	*TROQUE*	**TRO-kay**

ARTIFICIAL SAVAGE

In this time of desecularized "*desmodernidad*" [dis-modernity], as we approach the end of the millennium, anthropologists must learn to practice an ethnography of the artificial savage—much as they did before the extinction of so-called "natural savages" and the annihilation of "primitive" peoples—in the newly developed fields of "savage artificiality."

At the same time it has been necessary to encourage the creation of ironic new forms of savage artificiality. The performances of Guillermo Gómez-Peña and his collaborator Roberto Sifuentes are extraordinary examples of these newly emerging categories. Applying a corrosive irony to the diorama format, they simultaneously construct and dismantle the notion of the artificial savage. Such performance projects remind us that anthropology is, as Bronislaw Malinowski observed, the science of the sense of humor. This ironic definition, however, is not put into practice by most cultural scholars, who apparently prefer the staid security of academe. From its sedate halls they observe the behavior of Others, protected by the imposing sobriety of neoclassic columns.

Nothing is better to combat this academic solemnity than a healthy dose of kitsch—that by-product of the concept of *desmodernidad*, (i.e., living in permanent crisis or chaos à la *Mexicana*). In the words of Milan Kundera, "Kitsch provokes the rapid fall of two tears, one after the other. The first tear says 'How beautiful it is to see children running in the grass!' The second tear says 'How beautiful it is to be moved, together with all of humanity, by children running in the grass!'" An artificial savage specialist might state it differently: "How

BY ROGER BARTRA

VIDAS EJEMPLARES

LOS MÁRTIRES DEL RÍO DE LA PLATA

Año II No. 17
Noviembre 1987

beautiful it is to see 'Indians' fighting in the tropical jungle! How beautiful it is to be moved, together with all of humanity, by 'Indians' fighting in the tropical jungle!" The second tear, from the eyes of American and European progressives, is an ideal substance for embalming Indians and artificial savages.[1]

It could be argued that the notion of artificial savages is merely the invention of an irrational mind. Nothing is further from the truth. Artificial savages are fundamentally genuine Western beings, flesh-and-blood people with millennia-long traditions. When "Indians" fighting in the jungles of the Third World are perceived as tender noble savages, that vision comes straight from the tradition of good old artificial Western savages.

To illustrate this point, I propose an ethnographic expedition—a trip deep into America in search of these true, authentic savages.[2] Let's travel to the woods of Minnesota, in 1989, where a group of "wild men" assembles to take part in a "mythopoetic ritual." Women may not attend. The ceremony lasts two or three days, and begins with a "naming" exercise in which each man states his name, and then talks about his experiences. The wild men form a circle, create a ritual space and pass a baton from one to another. Following an Indian tradition, the person holding the baton may speak as long as he wishes without being interrupted.

When everyone has spoken, the men dance frenetically, beat drums, walk around on all fours like animals, howl, sniff each other, put on masks made during the meeting and butt each other with their heads like rams or stags. Underlying these actions is the belief that they must kill the child they still carry within in order to liberate a repressed internal masculine force, to connect with an Earth Father they have lost. From time to time someone recites lines of verse:

9

"Waspback children invade Santa Fe, 1999."

The strong leaves of the box-elder tree,
Plunging in the wind, call us to disappear
Into the wilds of the universe,
Where we shall sit at the foot of a plant,
And live forever, like the dust.

These rituals of wildness are part of a contemporary movement headed by poet Robert Bly, whose aim is to channel the frustrations felt by many men toward a new form of male liberation.[3] What is most interesting is that this sensitive poet of bucolic inspiration derived his ideas from the ancient myth of the wild man and based his interpretation on a story collected by the Grimm brothers in the nineteenth century. Though the process that has led thousands of men in the United States to channel their anxieties through the cult of the wild man is too complex to analyze here, one can, however, underline the disquieting fact that an ancient myth, reinterpreted by a poet, has managed to have such a deep influence in the heart of the most powerful industrialized society of our time.

Bly extracts a kernel from the medieval story of a wild man called Iron John, who was shut in a cage by the King and then liberated by his son. This story, according to Bly, suggests that deep in the psyche of every modern man lies a giant, hairy primitive being associated with sexuality and instinct. Contemporary culture, he says, must make contact with this wild man.[4] This Jungian-inspired interpretation suffers from the same failings as Erich Fromm's and Bruno Bettelheim's famous analyses of Little Red Riding

Hood: the attribution to the wild man of a symbolic function—akin to that assigned to the wolf, who devours Little Red Riding Hood and her grandmother—that makes sense only when seen as an ahistoric imposition of twentieth-century psychoanalytic dogma onto a myth whose highly complex development and widespread diffusion across centuries must be taken into account.[5]

The result of Bly's mythopoetic process is fundamentally, though unintentionally, kitsch. His wild men, in their exquisite artificiality, are more authentic than the Nambikwara described by Lévi-Strauss. Only in a performance by Gómez-Peña could they be adequately revealed and their movement critiqued—through irony—as a product of contemporary culture.

But herein lies a thorny problem. Social, political or ideological criticism—no matter how solid—focuses mainly on the rational threads of society, or rather its *supposedly* rational threads. Cultural criticism, on the other hand, generally wrestles with the emotional fiber of society, the textures of feeling related to myth and faith. Anthropologists know that risks are part of their profession, but the risks multiply when the focus is on society itself.[6] So when we speak about the criticism of culture, we touch the emotional or religious fibers of society, and when we speak ironically of artificial savages, we risk offending large segments of society, from the serious businessmen who relax on wild weekends to the jealous representatives of the authentic, natural and very noble Indians of the Third World.

These emotional fibers of society are connected with the unavoidable plurality of contemporary culture, which contributes to our notion of identity. Jacques Derrida has pointed out that a culture has an identity that can never be identified; it can only be defined in relation to its own differences.[7]

CIVILIZATION,

" On leaving the Royal Presence * * the Ojibbeway India

"HE TAILOR MAKES THE MAN."

h struck with the *red coat* and *gold lace* of Sykes, the Porter, and would not depart without shaking hands
at worthy functionary."---*Morning Paper*.

"White aborigines found at a Sydney nightclub," postcard from Australia.

We cannot, therefore, define cultural identities without simultaneously invoking the figure of Otherness. The Self does not exist without the Other. And any definition of the Other, necessarily, will have very diverse connotations, often acquiring negative and malignant tonalities with dangerous frequency.

When faced with those not like us—barbarians, those who are different—modern civilized cultures are learning to live together, recognizing that the presence of others is the surest guarantee of their own continuing existence and vitality. One of the most advanced acts of civilization is precisely that appreciation not only of ourselves, but of those who are different. The great Greek poet Cavafis expressed this notion well in the last four lines of his poem *Waiting for the Barbarians*:

> People returning from the border say
> that there are no longer barbarians.
> And what will become of us without barbarians?
> These men brought us solutions, after all.

We too can ask ourselves: "What will become of us without the savages?" The response has been that if there are no savages, we must invent them.

Guillermo Gómez-Peña proposes a permanent exercise in the invention of these savages: we must all invent our Other!

Gómez-Peña recently mined the enormous ironic potential of NAFTA [North American Free Trade Agreement], to create what he called an "end-of-the-century freak show extravaganza": he invented "Naftazteca," a cyber-pirate TV project, in which a "Cybervato" (Gómez-Peña's collaborator Roberto Sifuentes) and "El Naftazteca" (Gómez-Peña himself) create the enterprising roles of "post-NAFTA information-superhighway bandits" for a mainstream TV audience.

Some background: it was clear from the beginning that the pact to engage in free trade among the three countries of North America would create headaches for the governments of Canada, the United States and Mexico. One issue, which could have been marginal, has in fact engendered many misinterpretations and amusing cultural confrontations: language.

First of all, it is not clear why, in Mexico, NAFTA is not actually an *agreement*, but a *treaty* (*Tratado de Libre Comercio*, or *TLC*). Secondly, it is true that for entrepreneurial Mexico—which suffers from a high rate of functional illiteracy—*TLC* is as difficult to read as Wittgenstein's *Tractatus logico-philosophicus*. Thirdly, aggressive businessmen of the North, often suffering from political dyslexia, consider the Agreement—the compliance of the entrenched pre-modern and suspect monied class south of the Rio Grande—to be a great victory. Lastly, a veritable army of Mexican Cantinflas wannabes are busy inventing all sorts of witticisms and nonsense about

the fascinating *tractatus* which, having been approved, should now be deconstructed—dissolved in the waters of postmodernity.

This senseless accumulation of witticisms and *cantinflismos*, however, has not assuaged the fear that the dyslexic barbarians of the North will take advantage of virginal, nationalistic illiteracy and wrest the chastity belt off the Mexican entrepreneur. Many have experienced the embarrassing process of Washington's approval of NAFTA as a brutal rape performed in public.

If NAFTA [*TLC*] turns out to be a pact between illiterates and dyslexics—between pre-moderns and postmoderns—we had better prepare for a very strange voyage toward an uncertain future.

The most interesting aspect of this trip could be what occurs, as Don Quixote would say, between the lines: at the margins and behind the back of the free trade agreement treaty. The situation is fascinating. We are trapped in a pact cooked up by a gray Republican president, recycled by his bloodied, but triumphant, opposition, regarded disfavorably by the Canadian prime minister, and exalted by a moribund Mexican authoritarianism.

Začali jsme jim misto ohnivé vody dodávat pivo.

During the process of approving NAFTA the wires of the U.S. political system were crossed and some bizarre spectacles of political dyslexia broke out. A Texas billionaire became the champion of proletarian causes and the Democratic president led the Republican fight to approve NAFTA.

The performances of Guillermo Gómez-Peña and Roberto Sifuentes have given us an indispensable exercise in linguistics with which to survive the rigors of NAFTA. El Naftazteca, however, had to compete with incredible performances by the then president of Mexico. In one of the most sublime of shows—to an audience of students from all over Mexico—Salinas de Gortari declared that he didn't understand what happened in the U.S. during the heated discussions over the *TLC*. "It seemed as if we were the great power," he said, "and they were the small one." "¡*Ah Caray!*", he exclaimed, "they should have had more confidence in themselves...."

But then the *Temple of Confessions'* miraculous San Pocho Aztlaneca arrived on the scene, led by the Pre-Columbian Vato, to deconstruct gringos infected by a plague of dyslexia and Mexicans sunk in dysfunctional illiteracy. These artificial savages help us decipher the jargon of the U.S. government, suffering from a strange malady of language. We couldn't begin to understand American politics, much less survive its often catastrophic effects, without such artificial savages.

Translated by Professor Roberto Sifuentes. Edited by Nancy Jones and Daniel Power.

NOTES:

1. On the subject of kitsch, see the excellent reflections of Celeste Olalquiaga in Chapter 3 of her book *Megalopolis: Contemporary Cultural Sensibilities* (Minneapolis: University of Minnesota Press, 1992).

2. This "trip" is described in my book *The Artificial Savage*, translated by Christopher Follett (Ann Arbor: University of Michigan Press, 1996).

3. The verses quoted are by Robert Bly from "Poem in Three Parts" from his book *Silence in the Snowy Fields* (Middletown: Wesleyan University Press, 1962), reproduced by Bly in *Iron John* (Reading: Addison-Wesley, 1990).

4. Bly, *Iron John*.

5. Erich Fromm, *The Forgotten Language: An Introduction to the Understanding of Dreams, Fairy Tales and Myths* (New York: Rinehart, 1951); Bruno Bettelheim, *The Uses of Enchantment: The Meaning and Importance of Fairy Tales* (New York: Knopf, 1977). See Robert Darnton's devastating critique of these interpretations in "Peasants Tell Tales: The Meaning and Mother Goose," in *The Great Cat Massacre and Other Episodes in French Cultural History* (New York: Basic Books, 1984).

6. I have risked this kind of criticism in my book *The Cage of Melancholy* (New Brunswick: Rutgers University Press, 1992).

7. Jacques Derrida, *L'autre cap* (Parts: Les Editions de Minuit, 1991).

PINOLE

TARAHUMARA
BRAND

SUBTITLES

i have lived my life in a foreign film. Black and white mostly. Fassbinderish, i think. Having spoken one language in the five-room-flat secluded world of my grandmother until the age of six when i was sent to foreign film school—

hushhhh, i whispered the new language in fragmented sentences that jutted out of my mouth like broken glass caught in my throat. The first day when my older sister left me there, startled by the sudden appearance of subtitles at my feet, i ran out of the classroom.

i did enormously better than others back then, however, i have come to realize, when exchanging these early foreign film stories. Better than my old friend, Juana, who was sent to the class for the hearing-impaired for being unable to handle the subtitles. She did not learn the new language, she tells me. But she did become quite adept at signing.

In my school, however, there would have been no such luck. There was one alternative class alone, where all children who challenged their teachers for reasons not restricted to language difficulties were banished until they were old enough to drop out of school, six-year-olds with sixteen-year-olds: The Dumb Bell Room.

i, on the other hand, was not a foreigner—i was living in a foreign film. Typecast at times, especially during those formative years in the vast expanse of the inner-city—caught between African-American children with Mississippi accents and gypsy adult-like children who simply had no use for school at all after the second grade.

Miscast during what may have been the bloom of my womanhood, except for the fact that a renegade does not bloom so much as explode.

But later, oh finally, much later, i ascended with tenacity and confidence to the illustrious heights of stardom. And a star can be anything she wants.

So here i am. New casting. This is not a set. We are filming this scene on location. Spare no expense. And who would have ever thought...?

BY ANA CASTILLO

Passing through the music department. i am not six in this scene but thirty-eight now. The students, the professors are all foreign, of course. Yet, what is beautiful about all this, what was once so tormenting and now is the very source for my celebrity EVERYWHERE i go is that *i* am the one who is cast forever foreign. There is Mozart playing in the halls and the women are natural blonds. They appraise my Chichicastenango *huipil*. i smile at their naked stares. My dark fingers, rimmed with gold, reach up to my collarbone to rub the Virgen de Guadalupe/Tonantzin talisman medal that hangs from a thin gold chain.

i live, you understand, in a foreign film.

i have cultivated a disturbing but sensuous foreign

accent

like Ingrid Bergman's.

i don't always wear *huipiles* from Chichicastenango, Xela, or Mitla. i usually show off Spandex pants embroidered with silver roses, or a silk raincoat or Djuna Barnes red lipstick and wide brimmed hat or Marlene Dietrich waves or Kathryn Hepburn shoulders or a Greta Garbo cleft and i don't mean on the chin.

It is so hard to be

original.

Maria Sabina, Oaxacan shamaness peyote spell-caster suits my "type" best. If you can't be original, at least you can be complex.

i never disappoint my devoted public.

Traveling, not with *bruja* wings but on trains and jets to places Maria Sabina would not go, i find myself led to a place of foreignness of greater proportions than those created by the original script.

Behind a closed door at the end of the hall i recognize *Don Giovanni* on the piano. It is the only opera I have ever attended. A fortunate coincidence for me who can now turn casually to my host and smile: "Ah, *Don Giovanni*!" And he smiles back because the bridge i made by composition recognition makes him less uneasy with this unsolicited confrontation with otherness.

We reach the reception salon.

A dried flower arrangement at the center of the table. Domestic champagne. Platters of fruit and cheese. The usual.

Someone introduces herself and whispers in my ear. i throw my head back, laughing, a thousand rays of light radiate from the center of my being, à la Maria Sabina.

The cinematographer moves in for a close-up.

i have no lover. Neither on location nor back at the studios where my life is usually filmed. Another detail to note. It is certain to be relevant to the development of the plot.

Someone says in that pseudo-confident tone that ambitious people from general casting use in such scenes (nothing short of bad acting if you ask me), "She's a lesbian, you know."

The other extra, the one who has become involuntarily privy to this new information, strains her neck a bit, scrutinizes the star to see if she can determine this for herself:

Beneath the *huipil*, sheer black stockings with seams.

Red manicured fingernails.

Have we entered Monika Treut territory?

The protagonist is still laughing. Definitely not "Seduction: The Cruel Woman" material, the observer concludes of the star who is still doing Maria Sabina with a little bit of Nastassia Kinski.

We are into something only marginally Hollywood here. More along the lines of the Canadian metis-feminist genre, if there is one. A cross between "Loyalties" and "Getting a Winter Tan," maybe.

Another nobody-extra offers: "Actually, if she takes off that costume, she has breasts."

Big breasts?

It is all a matter of perspective. The cinematographer's.

I like her earrings. Detail is the director's forte. They are gold, of course, tiny Mayan masks.

Clues to her origin or just more visual effect to dazzle the viewer, like the little espresso coffeepot earrings on that weirdly beautiful actress in Almodovar's *fabulously* successful *Women on the Verge*....

Espresso is very European. Indian mask gold earrings are very American....

Indian from America. Where Columbus arrived, not where he was headed, but insisted that the inhabitants were Indian anyway.

Indigenous mask earrings cast from an original Mayan mold. You can count on that. Except that the originals were earplugs, going through the lobe in a much larger hole than the needle-thin one fashionable today. Holes were drilled into the teeth then as well, for adorning purposes. Embedded with precious gems. Trend setters those people were.

She is smiling gold and turquoise.

And starts to laugh again.

It is the domestic champagne. And the accent is getting thicker. Before you know it, she'll be speaking Mixtec.

She is not an actor.

She is not in costume.

She was born inside this film.

Her mother, who had birthed all her other children at home, was forced to a hospital with this last one. She gave her newborn daughter's name to the nun-nurse who immediately translated it. And thus, her career began.

Sometimes she cooks things, our star, but from no particular native cuisine. Yes, yes, she does mother-learned and grandmother-cherished recipes very well. She also does pesto and quiche with *molcajete* and *metate*. Very American, you know.

What isn't American these days with Gary Snyder declaring himself among the "New Indians of America?"

From across the room you can see that strange light emanating from her belly button.

What if she were Chinese? But, of course, not too tall.

Not too tall. What is it then?

She just isn't. Anyone can tell that. And you can't Anthony Quinn her into it, either.

She stops laughing, now sizing up the man with the full head of white hair and neatly trimmed beard, and assesses a potential development of the plot here. He could bring her gifts like St. Nick. Not just at Christmas.

Sometimes it's so hard to take her seriously.

She begins to fuss with her little Guatemalan change purse, the kind that is popular with Californian students these days, and pulls out two little photographs, passes them around. Everyone who examines them smiles politely, hands them to someone else. They are of a child who is a

very small version of

herself.

The child is away at school, she says.

Ah, of course.

Very bright, she says. Gets only the highest marks. Very sociable, too. Makes friends with everyone.

Of course.

He is going to be an artist when he grows up.

Oh? (Polite laughter here from those around her.)

Like his mother, she adds. And laughs again, putting the little photos that have been passed between index finger and thumb all around back into the little bag.

She has very thick, very black hair. It is natural.

Each time she laughs, either because of the champagne or because this is the only direction she has received so far in this scene, she runs her thin gold-rimmed fingers through the front of her hair. Gold with a pearl. Gold with black onyx. Gold and a diamond.

"You must catch the 19:04," someone alerts her. "The trains here are usually punctual."

"Yes, yes, don't worry!" she responds, almost flirtatiously although she didn't notice who in the crowd has spoken to her. It's certainly the champagne causing this sudden transformation of character. It doesn't make her giddy, but she would never smile

provocatively without the champagne, which is not a prop, but real.

The gathering is in her honor.

She is come to avenge the Conquest.

Don't make cheapshot Aztec jokes like: Will she cut any hearts out for an encore?

Of course, she will cut hearts out.

Just don't say it.

Don't ask if she will make it rain, either.

Maybe she will just do something mundane, like stare a bull down, later, in the scenes where she is resting in the countryside.

She reaches over to the table and with a silver pick helps herself to a piece of sheep cheese.

Cheap cheese?

Sheep cheese?

She repeats with her accent which, like the cheese, the locals have cultivated a certain taste for. The cheese is transported from Yugoslavia, unlike sheep milk which obviously sheep produce, to suckle baby sheep of course, and for Yugoslavs to produce cheese cheaply for export.

Enough of the cheese, and the strawberries too, cut into precise quarters to skirt the crystal platters.

Who will she sacrifice first?

The cast, for the most part, except for those cynics who would have guessed it, is unaware of her plan. Everyone is directed to move about the room, mingle cocktail party style, and assume that they have it all under control.

She is laughing a little again and you can see the ray of light from her center but cannot hear any sounds from her mouth. Kind of early Buñuel. Everyone appears oblivious and content.

Now, if she did have a lover, would it be a man lover?

The receptionists hold out their long-stemmed glasses to the new bottle of champagne (no, you cannot say receptionists for those attending a reception. They are guests, simply guests) and toast the Receiver. (She is not a Receiver, but the guest of honor.)

Translation is a vastly unappreciated art form.

If she does get a man lover on location or in this film at all, she wants him to have one of these strange names the people have here. They are ugly-sounding, actually, as if describing an organ transplant or a root-canal operation, or a food one wouldn't necessarily like to eat but surprisingly finds delicious, like cow brains or tongue.

But the men, apart from their names, are not necessarily ugly nor morbid in any apparent way, despite their Transylvanian accents, and she feels very certain that she could acquire a taste for one of them.

The women are much too tall for her liking, so they have all been dismissed. She doesn't see herself wearing Humphrey Bogart elevated shoes for the kissing scenes.

Engaging suddenly in an anarchy of mini melodramas, the supporting cast has begun to drift off. "Try to remember why we are all here, people!"

The director shouts through the megaphone, "At least *act* like you're interested!"

She is looking a little tired suddenly. Make-up! Make-up! Where the hell is that make-up person?

Full shot as she abruptly exits and hurries down the hall toward the lift.

Somebody stop her!

"i want to be alone," i say in a low tone.

"What? What did she say? What is it?"

"I'M GETTING MY PERIOD!" i shout. No one has directed me to say this, but i occasionally indulge my diva tendencies. Although with no-talent culture-appropriators like Madonna and Cher out there, what can you really do for shock effect these days, anyway? This, however, does freeze the cast, and the cinematographer and director for the moment let me go.

If you want to be alone, try living in an adobe in the desert. No one, with the exception of an occasional unwelcome rattlesnake or coyote, comes to visit, not even my child. My only human contact being when i go to the plaza to work out three times a week for two hours. Unlike celebrity sellouts, i cannot afford a private trainer and have to join the locals at the jazzercise class at the Y.M.C.A. It's hard to have a great body, Raquel Welch said recently, and she ought to know. While Rita Moreno, who made a big-time debut voluptuously dancing around to "I Want to be in America," now advertises her exercise video looking like a bulemic, along with the Klute radical, who seems to have started this all, forgoing international politics for staying in shape and making movies about foreigners. Victoria Principal, who looks foreign but is not, scammed a $300,000 advance for her exercise book and i suppose you could own your own trainer with that kind of money. But then, in a way not greatly advertised but brought out in a Barbara Walters interview for sure, she built a whole career based on scamming.

i do my own wax jobs, too.

Although there was a time when i definitely went *au naturel*. No, not in the 60s. Contrary to popular belief, i was not a flower child radical. In 1968 i was thirteen years old and playing an African American with a huge reddish-brown Afro wig, because the last thing i wanted to play then was

hippy and white.

And Martin Luther King was an American Gandhi at my school.

But being neither black nor white invalidated my existence.

And even without the wig, back in "The Godfather Lounge" on the southside of Chicago where i used to sneak in with false IDs, people saw the long straight hair and would ask incidentally of my Black and Proud look, "Do you have a little Indian blood?"

A little?

East Indian, maybe? Barbados?

i am

Coatlicue.

But no, not then, not yet. Then i was only a neophyte stone fertility filth-eating goddess. Not when i left the long black hair on my legs and underarms either, although yes, there i was, being something hard to pinpoint again, Muslim-looking perhaps, with the nosepin and the occasional sari.

No one knew how to cast me then. i might have been up for a dozen Oscars but for the fact that exotic types were rarely appreciated for their acting. It was just assumed that i was doing what came naturally to being Other, and obedient to rote training—like Bonzo or Lassie. And to my knowledge neither of them was ever nominated either, despite the fact that one co-starred with a minor actor who became president of the country.

And how grateful *i* should have been, for the pats on the head, but no, surely my unrefined breeding had something to do with my Marlon Brando temperament, insufferable and sulking, a complete antisocial, not to mention fatality incarnate to anyone who attempted intimacy—back then.

i could not stand the very idea of anyone who belonged in the movie stealing the scene, feeling too comfortable with her or his part, assuming i would eventually be moved off the set, dismissed. And more than a few did more than assume. "Get rid of her!" they demanded of the director. "She's got no training! Doesn't know a damn thing about Shakespeare!"

But who was doing Shakespeare? Surely none of them. Cecil B. DeMille convinced no one that Charleton Heston parted the Red Sea, nor did Otto Preminger's fresh discovery Jean Seberg make much of a Joan of Arc—although ironically, she was burned at the stake in the movie of her

life for being prophetic and unable to save her country, or rather, forbidden to do so, as happened to Joan.

In the desert i do not worry about honing my accent,

nor about my image. There isn't even a vague attempt at personal style. No make-up. Hair pulled back. In the plaza i look like any of the unemployed or underemployed women that stock their family pantries with 89-cent 32-oz. colas, dried chili powder, and blue corn *atole* in a box, who drive a 4 x 4, and maintain a fifteen-year marriage to a man who wears a baseball cap to cover a receding hairline and has a name like Santiago.

i look like any of them, but i am not any of them.

i drive a red sports car with a license plate that reads: TOLTECA. i wear a gold-plated Gucci watch—sent to me by a secret admirer, of course—nouveaurichely to the supermarket where i buy my cola and *atole*. i drink brandy with supper and listen to Astor Piazolla on my tape player as i cruise up I-40.

It comes with the territory of being a self-made star.

i have earned a local unflattering reputation for snubbing would-be suitors of either gender and being very particular about friendships in general. Stars are tolerated around here but not the self-assurance that often comes with their renown. But snubbing is not exactly based on snobbery. i would snub even if i were not famous. i tolerate very few people, which is why i moved alone to the desert, but cannot have enough of the world—whether it is the opera or

this desert, with its dust and tumbleweeds. The constant drone of the cicadas. The sweat cupped beneath my breasts when i sit perfectly still in the shade. The sound of the hard rain at night.

In a foreign film everything, inanimate and otherwise, is an object, a prop. But in the desert, especially at night with the rain, no one directs me to throw back my head and laugh. No one is intimidated by the light that radiates from my center. No one knows what i dream when i lie in the middle of an empty room on a futon and close my eyes to the spider webs that connect between *vigas* on the ceiling. The dreams are yet another film, less foreign than the one i live in out there, that you, dear public, need only spend an hour or so viewing, while i must continue inventing and reinventing my roles until death, for the sake of your entertainment.

BY RUBEN MARTINEZ

You I love
You I don't love
your breasts
your civil war
your asshole
my race war with you

Yes I want to dominate you
fuck you like a boy
and your white beneath my brown
approximates a historical revenge
as long as I love you
I hate myself just a little
and as long as I hate you
I hate myself even more

Is it your activist I lust
or the girl-next-door freckles...
am I your Third World centerfold?

You are as impossible
as I am impossible today
in this city that is an impostor
of itself
mutilated child of a city
gashing itself open with
 pre-revolutionary mayhem
and our love is apparently a model
for interethnic harmony!

I have failed to rise above my history
and yours:

CITY POEM #5

My brown, my cock, my busboy, my
 Latin Revolutionary, my Latin Lover,
 my gringo hater, my gringo lover,
 my middleclass-ness, my assassinated
 Indian, my mystical and haughty
 Spaniard, my gitano coarseness;

Your suburb, your Jewish memory,
 your American high school,
 your Cosmopolitan looks, your woman
 alone, your woman violated, your
 woman's pain and self-hatred, your
 pussy turned prison and your skin,
 your skin, your skin…

Every fight is a reenactment
a chance to settle scores
a chance for liberation
I cannot conquer my conqueror
you cannot forgive your conquering

(My rage is a volcano of history,
a caldron of molten resentment
that brings your orgasm quick every time)

All of which keeps us skating on
 the surface ice
where our love and sex
is swapped by the coin of history
and my denial is your comfort
as your denial would be the sex
I'd seek were the tables turned

The day my rage dissipates
the day I've become the Other
(or the day I live the fantasy of
 being the Other
ignoring that even then I'd be denied)
is the day you'll hate me
because I'd have become You
and my volcano would have to seek
other Others to destroy

(And what is beneath the surface?
Surely the mysteries, the healing
and transcendence of Love!
…bourgeois luxuries, fantasies?)

I ask myself how much of our love
issues up from deepest mystery
from God
sent us precisely to break free
from the chains of history

and I doubt history
and I doubt God
and I doubt you and I

on this doubting cross we wait
agonizing for history to end
for love to begin

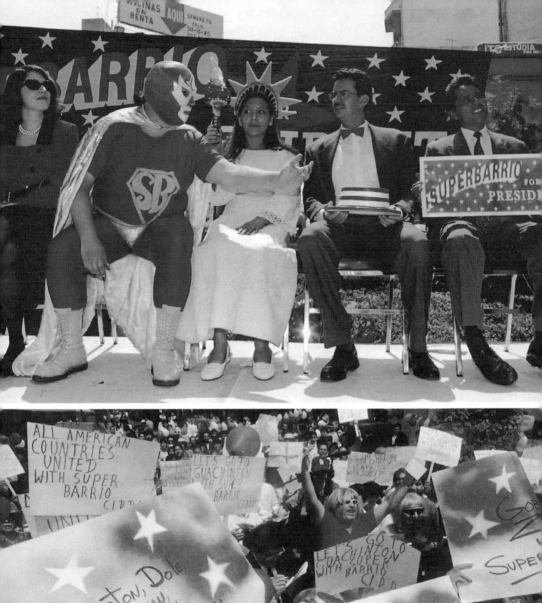
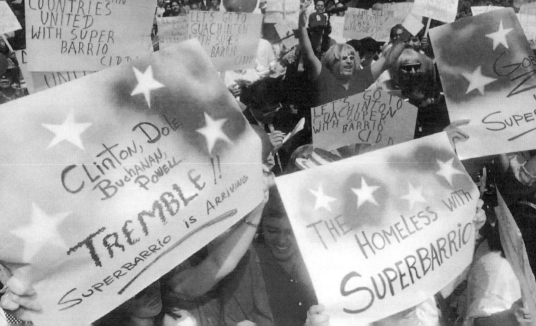

SUPERBARRIO
ANNOUNCES WHITE HOUSE BID

MEXICO CITY, March 20 (Reuters)—Mexican wrestler, spoof artist and social activist "Superbarrio" Gomez says he is running for the White House to protest the anti-immigrant rhetoric of the 1996 U.S. presidential campaign.

Wearing a cape and clad in Spandex, Superbarrio announced his presidential "bid" on Wednesday, demanding that everyone in the Americas be allowed to vote in the U.S. elections.

Only people born in the United States can be president.

Arriving at the launch of his spoof campaign in a white limousine flanked by trotting security guards, Superbarrio told supporters his slogan would be: "In Wetbacks We Trust."

"Wetbacks" is a derogatory term used in the United States to refer to illegal Mexican immigrants.

"There can be no economic integration if there is no political integration, if frontiers do not vanish along with the border patrol," Superbarrio said.

He slammed "the racist proposals of Bob Dole and Bill Clinton, the militarism of (Colin) Powell and the madness of (Pat) Buchanan."

Buchanan, in particular, has objected to immigration—both legal and illegal—to the United States in his campaign for the Republican presidential nomination.

Superbarrio, whose name means "Super Neighborhood," has campaigned in the past for housing for Mexico City's poor.

His campaigns often consist of wrestling matches against masked and caped opponents representing big business, speculators or Mexico's long-ruling Institutional Revolutionary Party. Superbarrio always wins.

CAN'T CROSS because Wilson & Clinton & Boxer & Feinstein & Dole & the Klan say so

CAN'T CROSS because it's Indian land stolen from our mothers

CAN'T CROSS because we're too emotional when it comes to our mothers

CAN'T CROSS because we've been doing it for over five hundred years already

CAN'T CROSS because it's too easy to say "I am from here"

CAN'T CROSS because Latin American petrochemical juice flows first

CAN'T CROSS because what would we do in El Norte?

CAN'T CROSS because Nahuatl, Mayan & Chicano will spread to Canada

CAN'T CROSS because Zedillo & Gortari are on vacation

CAN'T CROSS because the World Bank needs our abuelita's account

CAN'T CROSS because the CIA trains better with brown targets

CAN'T CROSS because our accent is unable to hide U.S. colonialism

CAN'T CROSS because what will the Hispanik MBAs do?

CAN'T CROSS because our suitcases are made with biodegradable maguey fibers

CAN'T CROSS because we still resemble la Malinche

CAN'T CROSS because our poetry is too oral & spontaneous

CAN'T CROSS because Mexico needs us to keep the peso from sinking

CAN'T CROSS because the Berlin Wall is on the way through Veracruz

CAN'T CROSS because we just learned we are Huichol

CAN'T CROSS because someone made our IDs out of corn

CAN'T CROSS because our border thirst is insatiable

CAN'T CROSS because we're on peyote & Coca-Cola & Banamex

CAN'T CROSS because our voice resembles La Llorona's

CAN'T CROSS because we are still voting

CAN'T CROSS because the North is really South

CAN'T CROSS because we can read about it in an ethnic prison

CAN'T CROSS because Frida beat us to it

CAN'T CROSS because U.S. & European corporations would rather visit us first

CAN'T CROSS because environmental U.S. industrial pollution suits our color

CAN'T CROSS because of a new form of overnight Mayan anarchy

CAN'T CROSS because there are enough farmworkers in California

CAN'T CROSS because we're meant to usher in a postmodern gloom into Mexico

BY JUAN FELIPE HERRERA

AN EMERGENCY PERFORMANCE POE

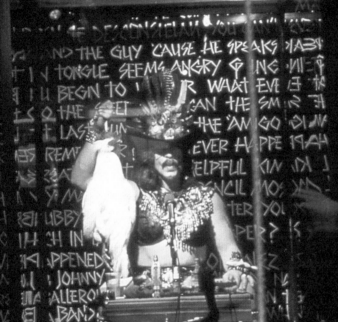

CAN'T CROSS because Nabisco, Exxon & Union Carbide gave us Mal de Ojo

CAN'T CROSS because Kathie Lee's molé print overalls at Wal-Mart are smeared with our DNA

CAN'T CROSS because it's better to be rootless, unconscious & rapeable

CAN'T CROSS because we're destined to have the "Go Back to Mexico" blues

CAN'T CROSS because of Pancho Villa's hidden treasure in Chihuahua

CAN'T CROSS because of Bogart's hidden treasure in the Sierra Madre

CAN'T CROSS because we need more murals honoring our Indian past

CAN'T CROSS because we are really dark French Creoles in a Cantinflas costume

CAN'T CROSS because of this Aztec reflex to sacrifice ourselves

CAN'T CROSS because of this Spanish penchant to be polite and aggressive

CAN'T CROSS because we had a vision of Sor Juana in drag

CAN'T CROSS because we smell of tamales soaked in tequila

CAN'T CROSS because we got hooked listening to Indian jazz in Chiapas

CAN'T CROSS because we're still waiting to be cosmic

CAN'T CROSS because the passport says we're out of date

CAN'T CROSS because first we need to sweep the adobe floors again

CAN'T CROSS because our organ donor got lost in a bingo game

CAN'T CROSS because we're too calm & appreciative of our Capitalist neighbors

CAN'T CROSS because our 500-year penance was not severe enough

CAN'T CROSS because we're still running from la Migra

CAN'T CROSS because we're still kissing the Pope's hand

CAN'T CROSS because we're still practicing to be Franciscan priests

CAN'T CROSS because they told us to sit & meditate & chant Nosotros Los Pobres

CAN'T CROSS because of the word "Revolución" & the words "Viva Zapata"

CAN'T CROSS because we rely more on brujas than lawyers

CAN'T CROSS because we never finished our PhD in Total United Service

CAN'T CROSS because our identity got mixed up with passion

CAN'T CROSS because we have visions instead of televisions

CAN'T CROSS because our huaraches are made with Goodyear & Uniroyal

CAN'T CROSS because the pesticides on our skin are still glowing

CAN'T CROSS because it's too easy to say "American Citizen" in cholo

CAN'T CROSS because the Unabomber will shrinkwrap our enchiladas

CAN'T CROSS because our comadres are an International Political Party

CAN'T CROSS because for us the universe is one big barrio

CAN'T CROSS because we're holding our breath in the Presidential Palace in Mexico City

CAN'T CROSS because every Mexican is a Living Theatre of Rebellion

CAN'T CROSS because Hollywood needs its subject matter in folkloric decor

CAN'T CROSS because the Grammys & MTV are finally out in Spanish

CAN'T CROSS because the Right is writing an epic poem of apology for our proper edification

CAN'T CROSS because the Alamo really is pronounced "Alamadre"

CAN'T CROSS because the Mayan concept of zero means "U.S. Out of Mexico"

CAN'T CROSS because the oldest Ceiba in Yucatan is prophetic

CAN'T CROSS because England is making plans

CAN'T CROSS because we're macho & will take it in the ass

CAN'T CROSS because the Contras will work it out for us

CAN'T CROSS because we can have Nicaragua, Honduras & Panama anyway

CAN'T CROSS because 90 million Mexicans can be wrong

CAN'T CROSS because we'll smuggle an earthquake into New York

CAN'T CROSS because we'll organize like the Vietnamese

CAN'T CROSS because East L.A. is sinking

CAN'T CROSS because the Christian Coalition doesn't cater at Cesar Chavez Parque

CAN'T CROSS because you can't make mace out of beans

CAN'T CROSS because the computers can't pronounce our names

CAN'T CROSS because the National Border Police are addicted to us

CAN'T CROSS because Africa will follow

CAN'T CROSS because we're still dressed in black rebozos

CAN'T CROSS because we might sing a corrido at any moment

CAN'T CROSS because our land grants are still up for grabs

CAN'T CROSS because our tattoos are indecipherable

CAN'T CROSS because people are hanging milagros on the 2000 miles of border wire

CAN'T CROSS because we're locked into Magical Realism

CAN'T CROSS because Mexican dependence is a form of higher learning

CAN'T CROSS because making tortillas leads to plastic explosives

CAN'T CROSS because we've been conquered by the Spanish & the U.S. medfly

CAN'T CROSS because we eat too many carbohydrates

CAN'T CROSS because a quinceañera will ruin the concept of American virginity

CAN'T CROSS because huevos rancheros are being served at Taco Bell as Wavoritos

CAN'T CROSS because every Mexican grito undermines English intonation

CAN'T CROSS because the President has a Mexican maid

CAN'T CROSS because the Vice President has a Mexican maid

CAN'T CROSS because it's Rosa Lopez's fault O.J. Simpson is guilty

CAN'T CROSS because Banda music will take over the White House

CAN'T CROSS because Aztec sexual aberrations are still in practice

CAN'T CROSS because our starvation & squalor isn't as glamorous as Somalia's

CAN'T CROSS because agribusiness will fuck us over anyway

CAN'T CROSS because the information highway is not for Chevys & Impalas

CAN'T CROSS because white men are paranoid of Frida's mustache

CAN'T CROSS because the term "mariachi" comes from the word "cucarachi"

1970s

Two Brazilian performance artists exhibit themselves as "clean and disinfected Latin Americans."

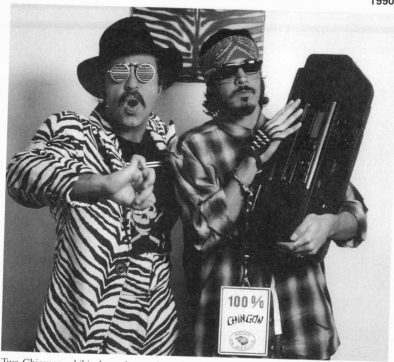

Two Chicanos exhibit themselves as the incarnation of America's fears and desires.

CAN'T CROSS because picking grapes is not a British tradition

CAN'T CROSS because they are still showing *Zoot Suit* in prisons

CAN'T CROSS because Richie Valens is alive in Iowa

CAN'T CROSS because *? & the Mysterians* cried 97 tears not 96

CAN'T CROSS because Hoosgow, Riata, Rodeo are Juzgado, Riata and Rodeo

CAN'T CROSS because Brazil will blow as soon as we hit Oceanside

CAN'T CROSS because U.S. narco-business needs us in Nogales

CAN'T CROSS because the term "Mexican" comes from "Mexicanto"

CAN'T CROSS because it's better to say "Latino" than "Mexicanto"

CAN'T CROSS because Mexican fairies crossed already

CAN'T CROSS because Mexican lesbians wear Ben Davis & sombreros de palma to work

CAN'T CROSS because VFW halls aren't built to serve cabeza con tripas

CAN'T CROSS because we'll kick Newt Gingrich's ass

CAN'T CROSS because we'll kick Pete Wilson's ass

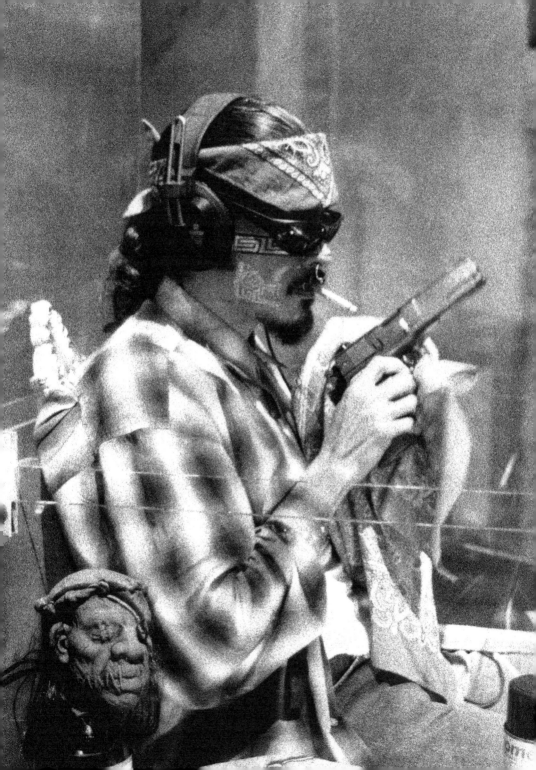

CAN'T CROSS because we still bury our feria in the backyard

CAN'T CROSS because we don't have international broncas for profit

CAN'T CROSS because we are in love with our sister Rigoberta Menchú

CAN'T CROSS because California is on the verge of becoming California

CAN'T CROSS because the PRI is a family affair

CAN'T CROSS because we know how to pronounce the name "Sandino"

CAN'T CROSS because we may start a television series called *No Chingues Conmigo*

CAN'T CROSS because we are too sweet & obedient & confused & (still) full of rage

CAN'T CROSS because the CIA needs us in a Third World state of mind

CAN'T CROSS because brown is the color of the future

CAN'T CROSS because we turned Welfare into El Huero Felix

CAN'T CROSS because we know what the Jews have been through

CAN'T CROSS because we know what the blacks have been through

CAN'T CROSS because the Irish became the San Patricio Corps at the Battle of Churubusco

CAN'T CROSS because of our taste for Yiddish gospel raps & tardeadas & salsa limericks

CAN'T CROSS because El Sistema Nos La Pela

CAN'T CROSS because the Hmong enjoy our telenovelas

CAN'T CROSS because Chicana Hell's Angels graffiti at Safeway is un-American

CAN'T CROSS because we'd rather shop at the flea market than at Macy's

CAN'T CROSS because pan dulce feels sexual, especially conchas & the elotes

CAN'T CROSS because we'll Xerox tamales in order to survive

CAN'T CROSS because we'll export salsa to Russia & call it "Pikushki"

CAN'T CROSS because cilantro aromas follow us wherever we go

CAN'T CROSS because we'll unionize & sing *De Colores*

CAN'T CROSS because in Los Angeles the Macarena is a martial art

CAN'T CROSS because we're in touch with our Boriqua camaradas

CAN'T CROSS because we are the continental majority

CAN'T CROSS because we'll build a sweat lodge in front of Bank of America

CAN'T CROSS because Gortari can't keep a juice fast

CAN'T CROSS because we should wait for further instructions from Televisa

CAN'T CROSS because 90 million Mexicanos are potential Chicanos

CAN'T CROSS because we'll take over the Organic Foods business with a molcajete

CAN'T CROSS because 2000 miles of maquiladoras want to promote us

CAN'T CROSS because the next Olympics will commemorate the massacre of 1968

CAN'T CROSS because there is an Aztec temple beneath our Nopales

CAN'T CROSS because we know how to pronounce all the Japanese corporations

CAN'T CROSS because the Comadre network is more accurate than CNN

CAN'T CROSS because the Death Squads are having a hard time with Caló

CAN'T CROSS because the mayor of San Diego likes salsa medium-picante

CAN'T CROSS because the Navy, Army, Marines like us topless in Tijuana

CAN'T CROSS because when we see red, white & blue we just see red

CAN'T CROSS because when we see the numbers 187 we still see red

CAN'T CROSS because we need to pay a little fee to the Border

CAN'T CROSS because Mexican Human Rights sounds too Mexican

CAN'T CROSS because Chicano Power is alive & well in Fowler

CAN'T CROSS because Chrysler is putting out a lowrider

CAN'T CROSS because they found a lost Chicano tribe in Utah

CAN'T CROSS because harina bag suits don't cut it at graduation

CAN'T CROSS because we'll switch from AT&T & MCI to Y-que, y-que

CAN'T CROSS because our hand signs aren't registered

CAN'T CROSS because "lotto" is another Chicano word for "pronto"

CAN'T CROSS because we won't nationalize a State of Immigrant Paranoia

CAN'T CROSS because the depression of the 30s was our fault

CAN'T CROSS because "xenophobia" is a politically correct term

CAN'T CROSS because we should have learned from the Chinese Exclusion Act of 1882

CAN'T CROSS because we should've listened to the Federal Immigration Laws of 1917, '21, '24 & '30

CAN'T CROSS because we lack a Nordic/Teutonic approach

CAN'T CROSS because we still wear Zoot suits to Halloween

CAN'T CROSS because Executive Order 9066 of 1942 should've had us too

CAN'T CROSS because Operation Wetback took care of us in the 50s

CAN'T CROSS because Operation Clean Sweep picked up the loose ends in the 70s

CAN'T CROSS because one more operation will finish us off anyway

CAN'T CROSS because we have a heart that sings rancheras and feet that polka

THE HEAD

OF THE RENOWNED BANDIT

JOAQUIN!

WILL BE

EXHIBITED

FOR ONE DAY ONLY

AUG. 19, 1853 - AT THE STOCKTON HOUSE

- PLUS -

THE HAND

OF THE NOTORIOUS
ROBBER AND MURDERER

THREE FINGERED JACK

JOAQUIN and THREE - FINGERED JACK were captured by the State Rangers under the command of Captain Harry Love at the Arroya Cantina, July 24th. No reasonable doubt can be entertained in regard to the identification of the head now on exhibition as being that of the notorious robber, Joaquin Murietta, for it is recognized by hundreds of persons who have formerly seen him and described him as illustrated in the splendid etching that accompanies this happy announcement.

AS FURTHER PROOF, the hand of Joaquin's evil accomplice, Three-Fingered Jack Garcia, has been removed from its more ordinary position and is preserved in a jar of alcohol for display at the public exhibition.

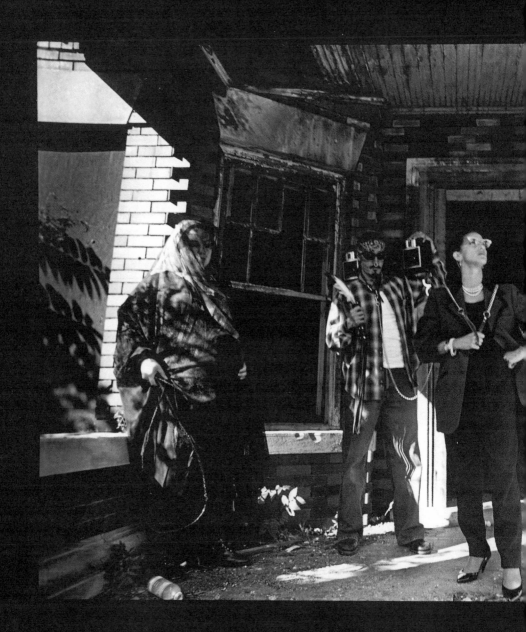

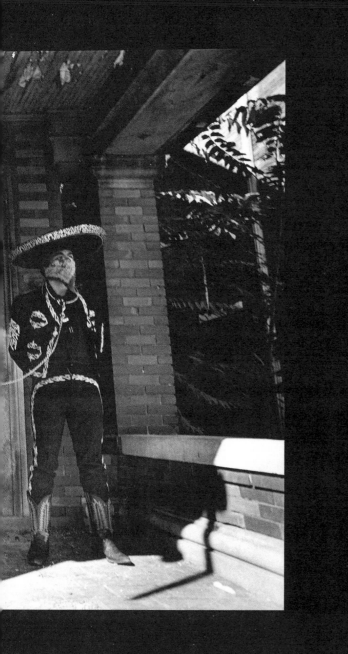

19A

cause th...
...corated with pa...
...ious persuasio...
...ut as pop cultu...
...le his multidi...
...avant-garde

Roy Rogers

...no in 1991 receiv...
...owship, or "gen...
...bilingual poet and...
...rtist who makes...
...nentaries. His lan-
...lush, and he talks
...now immigrants are
...w that the commu-
...

...esn't believe in the
...ultures. He is a born
...uralist. Each culture
...that which it shares.
...lving the us-versus-

...taking p...
Pena, of being o...
"Thousands of pe...
on us, and that is...
kneeling in front o...
you horrible thing...
credible expressio...
solidarity can also...
moving. You have...
emotionally and no...
Whathar "Th

gs of women of
black velvet —
s one can get —
sional mix is a
approach.

being part of the
timate. While a
t incense, anoth-

the great murals by ar
Diego Rivera. "To our
major artwork has bee
influential. It is perha
portant artistic gestu
Mexican outside of M

Gomez-Pena and S
performing live today t
will be replaced by
ins through Nov.
her performance a
na," at 8 p.m. V
e joined by Coc
forum about their

mike and tellin
is too sad.
tenderness a
come extrem
detach yours
e it personall

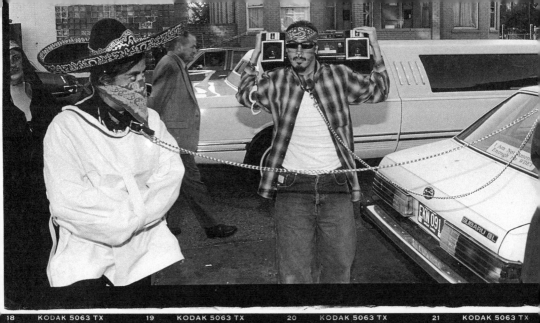

Often, when we arrive in the city where the performance is about to take place, we carry out a series of "street interventions" meant to generate curiosity among people who wouldn't normally know about art events. Dressed in character we are driven in a white limousine to politically—or historically—charged sites in the city and paraded on dog leashes through the streets by an elegantly dressed corporate woman. After witnessing these interventions or their coverage on the local TV news, the public begins to generate mythologies around the *Temple* and our presence in the city. These photographs document a "street intervention" which took place in Detroit, a week prior to the opening of the *Temple of Confessions* at D.I.A.

They put a price on us.
The price for a
young person,
for a priest,
a child or a young girl.
And it was enough;
for a common man
the price was only
two handfuls of corn
or ten portions of caked
mosquitoes;
our price was only
twenty portions of salty
witch grass.
Gold, jade,
rich mantles,
plumage of quetzal,
all that has value
was then counted
as nothing...

From the *Elegies of*
the Aztec World

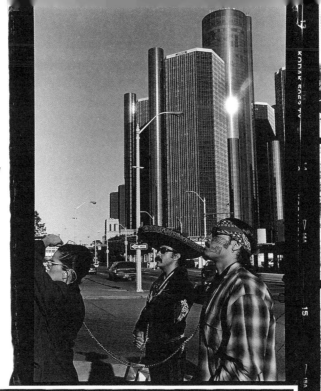

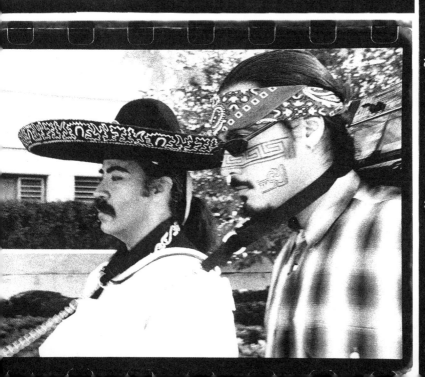

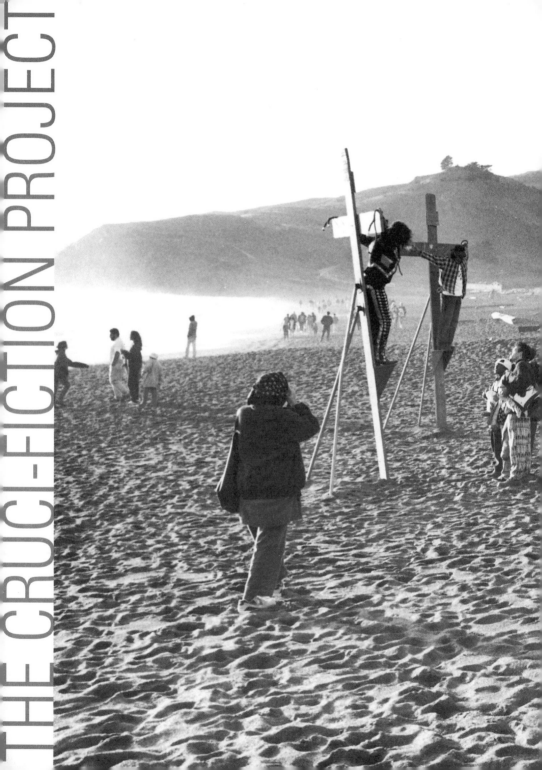

THE CRUCI-FICTION PROJECT

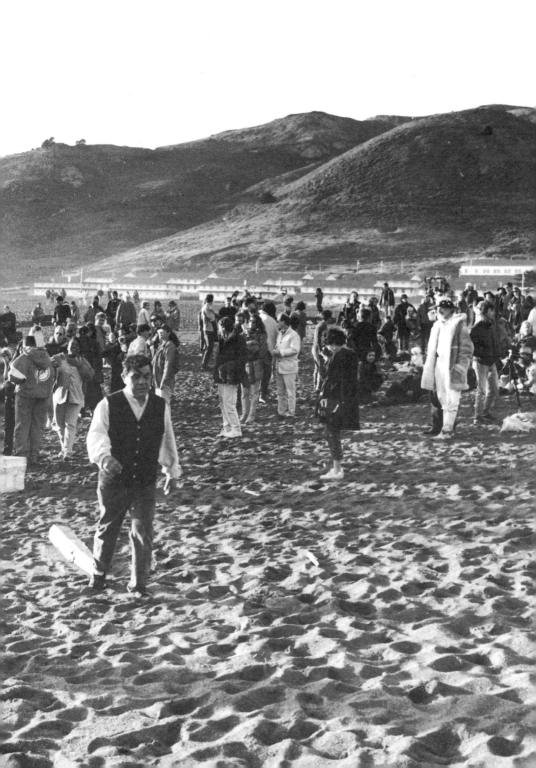

"Christ is missing today..."
—Cruci-Fiction Project flyer

On the evening of April 10, 1994, one week after Easter Sunday, an unusual "end-of-the-century performance ritual" took place at Rodeo Beach in the Marin Headlands Park across from San Francisco's Golden Gate Bridge. My collaborator Roberto Sifuentes and I crucified ourselves for three hours on two sixteen-by-twelve-foot wooden crosses. We were dressed as "the two contemporary public enemies of California." I, wearing a 1950s gala mariachi suit, was the "undocumented bandito," crucified by America's fears of cultural otherness. Inscribed on the cross above me were the letters "INS" (Immigration and Naturalization Service). To my left, costumed in stereotypical lowrider attire, his face covered with tattoos, Roberto posed as a "generic gangmember," with the letters "LAPD" (Los Angeles Police Department) written above his head. A children's gospel choir, a troupe of Japanese *taiko* drummers, a group of puppeteers and several fire artists contributed to the event.

BY GUILLERMO GOMEZ-PENA

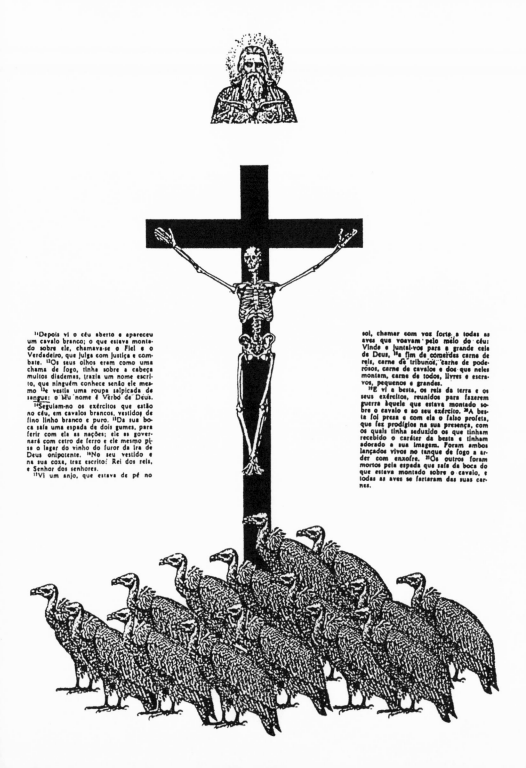

¹¹Depois vi o céu aberto e apareceu um cavalo branco; o que estava montado sobre ele, chamava-se o Fiel e o Verdadeiro, que julga com justiça e combate. ¹²Os seus olhos eram como uma chama de fogo, tinha sobre a cabeça muitos diademas, trazia um nome escrito, que ninguém conhece senão ele mesmo ¹³e vestia uma roupa salpicada de sangue: o seu nome é Verbo de Deus.

¹⁴Seguiam-no os exércitos que estão no céu, em cavalos brancos, vestidos de fino linho branco e puro. ¹⁵Da sua boca saía uma espada de dois gumes, para ferir com ela as nações; ele as governará com cetro de ferro e ele mesmo pisa o lagar do vinho do furor da ira de Deus onipotente. ¹⁶No seu vestido e na sua coxa, traz escrito: Rei dos reis, e Senhor dos senhores.

¹⁷Vi um anjo, que estava de pé no sol, chamar com voz forte a todas as aves que voavam pelo meio do céu: Vinde e juntai-vos para a grande ceia de Deus, ¹⁸a fim de comerdes carne de reis, carne de tribunos, carne de poderosos, carne de cavalos e dos que neles montam, carne de todos, livres e escravos, pequenos e grandes.

¹⁹E vi a besta, os reis da terra e os seus exércitos, reunidos para fazerem guerra àquele que estava montado sobre o cavalo e ao seu exército. ²⁰A besta foi presa e com ela o falso profeta, que fez prodígios na sua presença, com os quais tinha seduzido os que tinham recebido o caráter da besta e tinham adorado a sua imagem. Foram ambos lançados vivos no tanque de fogo a arder com enxofre. ²¹Os outros foram mortos pela espada que saía da boca do que estava montado sobre o cavalo, e todas as aves se fartaram das suas carnes.

This "Cruci-Fiction Project" was part of a larger "ritual of spiritual transformation" organized by Chicano counter-cultural capo René Yáñez and alluded to the biblical tale of Dimas and Gestas, the two legendary and somewhat anonymous thieves who were hung next to Jesus Christ.

Sadly, the public punishment and symbolic crucifixion of "undesirables" is still a common practice in the so called "Western democracies." In California and other southwestern states, migrant workers and Latino youths are being blamed by politicians and sectors of the mainstream media for the increase in crime and drugs in our city streets, the present financial

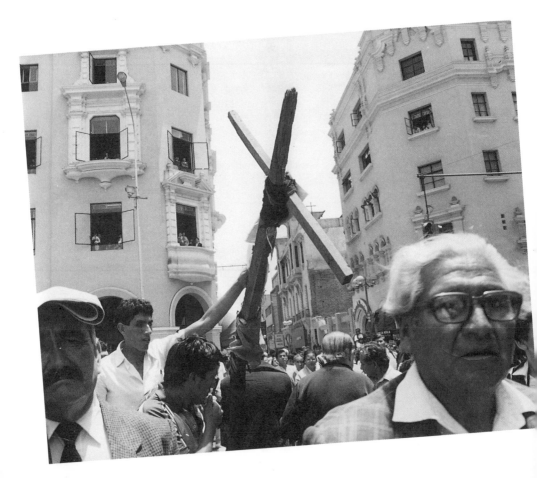

crises, and the deterioration of our country's social, cultural and educational institutions. In other words, these vulnerable communities are in fact being symbolically crucified by the state. In response to this trend, and to the panic politics of California governor Pete Wilson, Roberto and I decided to replace the identities of the biblical thieves with those of the mariachi, a Mexican folk musician often perceived by depoliticized Americans as the quintessential "greaser" or "bandito"; and the lowrider, who has become synonymous with "gangmember."

With the help of friends, Roberto and I climbed the crosses around 6:30 P.M. Our wrists were strapped to the cross with rope. It was very windy, and the sun was slowly sinking over the Pacific ocean behind our backs. Fliers were handed out to a crowd of over 300 people, asking them to "free us from our martyrdom and take us down from the crosses as a gesture of political commitment."

We naively thought it would take them approximately forty-five minutes to an hour to figure out how to get us down without a ladder. But we miscalculated. Mesmerized by this melancholy scene, and by the strangeness of the event, it took them over three hours, first to realize that our lives were literally in danger, then to figure out how to get us down. By 9:45 P.M. René and the *taiko* drummers decided they had to take action. They formed a human pyramid to untie us. By then my right shoulder had become dislocated, and Roberto had almost passed out. Our tongues,

torsos, arms and hands had lost all feeling, and we were barely able to breathe from the pressure of the rib cage on the lungs. We were then carried by some performers and audience members to a nearby bonfire and slowly nurtured back to full consciousness with water and massage. A friend put my swelling shoulder back into place. Others in the crowd rebuked those helping us, screaming: "Let them die!" It felt like a strange reenactment of a biblical scene.

Though Roberto and I were clearly aware of the impact our action would have on the "live audience" present at the beach, "The Cruci-Fiction Project" was mainly staged for the media. The choice of the site, the cinematic placement of the crosses, and the dramatic time of

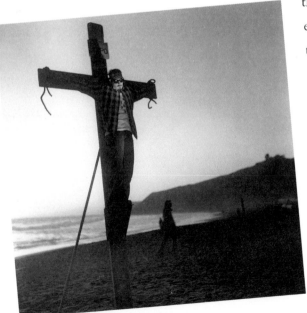

the day made the *tableau vivant* extremely photogenic. The photographers went wild. Images of the event were immediately picked up by the media. Within a week and a half, the piece became international news, appearing in, among other publications, *Der Speigel* (Germany), *Cambio 16* (Spain), the Mexican dailies *Reforma*

and *La Jornada*, and various U.S. newspapers, art publications and radio programs. And with the exception of *Cambio 16*, which reported that Roberto and I were in fact a real mariachi and "gangmember" acting out of political desperation, the media clearly understood that our project was a performance art piece, a symbolic protest against xenophobia. Photos of the project still continue to reappear in news media and art publications as the debates on immigration and arts 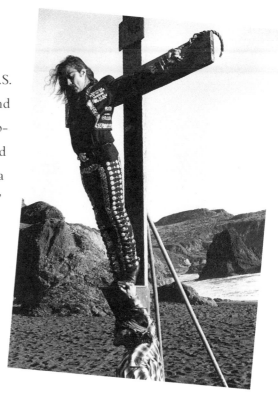 funding become the focus of the political right. In an article about the National Endowment for the Arts, illustrated with a close-up of my face on the cross, *Artweek* magazine questioned our alleged (and totally untrue) use of NEA (public) funds in the performance.

"The Cruci-Fiction Project" has now crossed into the realms of the mythical and the vernacular. As Roberto and I tour the country with other projects, people we meet on the road often ask us if we have heard of "the two crazy Mexicans" who crucified themselves somewhere in L.A., on the U.S.-Mexico border, or in San Francisco. Their descriptions of the objective of the piece differ slightly: the "crazy Mexicans" were protesting, alternately, *la migra* [the border patrol], police brutality, NAFTA, "English Only," the California governor or the Mexican government.

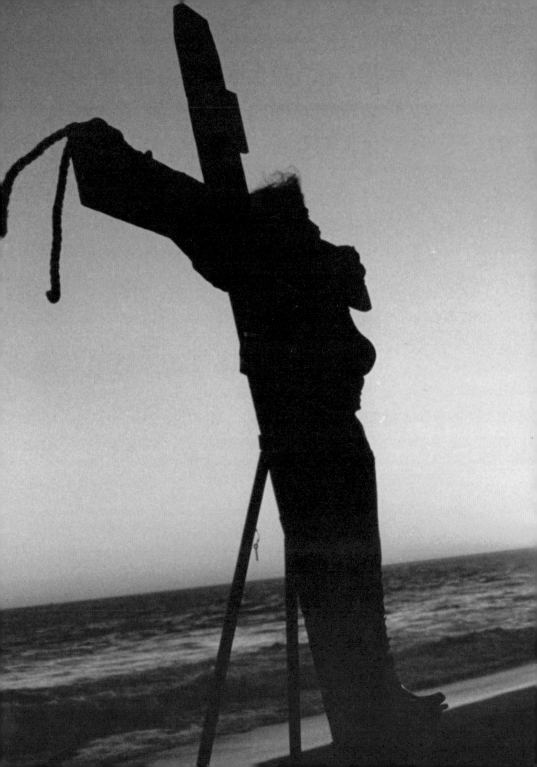

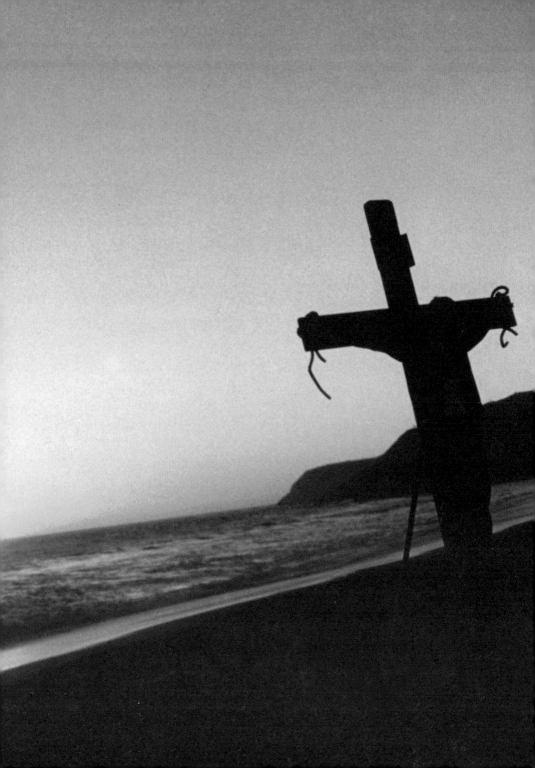

In these anecdotal descriptions, the performative protestors often "used real nails," "spent several days on the crosses," "ended up in jail," or even "were deported back to Mexico." Since we believe that performance is merely another way to tell social truths, we try to not correct any of these versions.

In Las Cruces, New Mexico, after a lecture at the university, a local artist gave us a sealed envelope, "to be opened later on in private." It contained an extremely dramatic photograph: somewhere in Mexico (it looked like Taxco or San Miguel Allende), the artist, a very beautiful blond woman in her early- to mid-30s, had crucified herself to a wooden cross in what appeared to be an act of cultural penance.

On October 4, 1995, a strange coincidence occurred. A Mexico City policeman named Ricardo Chaires Coria crucified himself on a wooden cross right in front of the monument of El Angel de la Independencia to protest poor wages and police corruption. Wearing his uniform, his chubby body was wrapped with tape and rope to the cross. He actually managed to stay seven hours on the cross. The traffic on Reforma Avenue was practically paralyzed the entire time. When his colleagues finally decided to bring him down, he was near death. Images of this event were picked up by the media and became international news.

Last month, a neighbor showed me the fate of one of the myriad photos of "The Cruci-Fiction Project": a hip San Francisco "Greetings" card. There was no description of the event, much less the politics behind it. Roberto's name was left out and mine was misspelled. Perhaps this is the real fate of political art at the end of the century.

SCRIPTURE 187:95

BY RUBEN MARTINEZ

BROTHERS AND SISTERS!
¡HERMANOS Y HERMANAS!

WE'VE GATHERED TOGETHER TO HEAR THE WORD, PRAISE THE
LORD, ¡ALABADO SEA EL SENOR!
THE WORD/LA PALABRA
THE WORD/LA PALABRA
THE WORD,
HERMANOS Y HERMANAS
BROTHERS AND SISTERS...

THE SCRIPTURE SAYS:
"BEWARE! FOR THEY WILL DELIVER YOU UP TO COUNCILS, AND
SCOURGE YOU IN THEIR SYNAGOGUES, AND YOU WILL BE
BROUGHT BEFORE GOVERNOR PETE WILSON FOR MY SAKE..."

AND YOU WILL BE HATED BY ALL FOR MY NAME'S SAKE; BUT HE
WHO HAS PERSEVERED TO THE END WILL BE SAVED...

SO, BROTHER, SO, HERMANA, WHEN LA MIGRA TRACKS YOU
DOWN IN EAST L.A., FLEE, HERMANO, RUN, SISTER, TO ANAHEIM!
AND IF THE MIGRA FIND YOU IN ANAHEIM, HEAD OUT TO
MONROVIA! AND IF IN MONROVIA THE DREADED
FORCES HUNT YOU, THEN IT IS TO FRESNO THAT
YOU SHALL GO! AND SO ON...

AMEN I SAY TO YOU, THERE WILL NOT BE LEFT HERE ONE STONE
UPON ANOTHER THAT WILL NOT BE THROWN DOWN...

FOR NATION WILL RISE AGAINST NATION, AND KINGDOM
AGAINST KINGDOM, AND THERE WILL BE PESTILENCES AND
FAMINES AND EARTHQUAKES IN VARIOUS PLACES...

AND MANY WILL BETRAY ONE ANOTHER AND WILL HATE ONE
ANOTHER

16 DE SEPTIEMBRE Y 9 ORIENTE.
PUEBLA. PUE.

NIÑO CIEGUITO
DE CAPUCHINAS.

AND MANY FALSE PROPHETS—LIKE PETE WILSON AND MIKE
HUFFINGTON AND DIANNE FEINSTEIN AND BARBARA BOXER—
ARISE AND WILL LEAD MANY ASTRAY.

BUT REMEMBER THAT "BLESSED ARE THEY WHO SUFFER
PERSECUTION FOR JUSTICE'S SAKE, FOR THEIRS IS THE KINGDOM
OF HEAVEN..."

PROPOSICION 187 HAS PASSED IN CALIFORNIA, BROTHERS AND
SISTERS!

SHIP THE ILLEGALS BACK TO OLD MEXICO!

ROUND UP THE KINDERGARTENERS!

SHOVE THE PREGNANT MOM INTO THE SEA-GREEN BORDER VAN!

WHILE YOU'RE AT IT, DIG UP MY GRANDPARENTS
FROM THEIR FOREST LAWN GRAVES,
DEPORT THEIR CASKETS TO COAHUILA AND ZACATECAS!

MY GRANDPARENTS, MIS QUERIDOS ABUELITOS
THEY CAME NORTH TO CALIFORNIA
LOOKING FOR THE PROMISED LAND
WORKED THEMSELVES INTO ALCOHOLISM
AND HEART ATTACKS FOR THE AMERICAN DREAM
THESE ARE THE PEOPLE THAT DON PEDRO WILSON CALLS
WELFARE FREELOADERS...

NEWS FLASH!
THIS JUST IN:
CIVIL RIGHTS ORGANIZATIONS HAVE RECEIVED THOUSANDS OF
CALLS FROM LATINOS ALLEGING HARASSMENT SINCE THE
ELECTION

+ A MEXICAN AMERICAN MOTHER CALLED TO SAY HER SICK
TWO YEAR OLD HAD BEEN LEFT WAITING FIVE HOURS AT
KAISER HOSPITAL. FINALLY SHE WAS ADMITTED TO THE HOSPITAL.

THE CHILD WAS NEAR DEATH. THEN AN ATTENDANT ASKED
THE MOTHER—AN AMERICAN CITIZEN—TO SHOW HER
IMMIGRATION PAPERS.

✦ TWO LATINAS IN SACRAMENTO SAID THAT POLICE PICKED
THEM UP FOR JAYWALKING AND THEN ASKED THEM FOR
PAPERS. THEY TOLD THE OFFICERS THEY WERE LEGAL
RESIDENTS. ONE OF THE POLICEMEN ALLEGEDLY SAID "WE CAN
SEND YOU BACK TO TIJUANA, MAMA!"

✦ A PALM SPRINGS PHARMACY DEMANDED IMMIGRATION
DOCUMENTS BEFORE FILLING A PRESCRIPTION FOR A
CUSTOMER'S DAUGHTER, AN AMERICAN CITIZEN.

✦ A CUSTOMER AT A RESTAURANT IN SANTA PAULA DEMANDED
 TO SEE THE COOK'S GREEN CARD.

OH CALIFORNIA, WOE CALIFORNIA!
OH CALIFORNIA, WOE CALIFORNIA!

YO SOY DE MERO CALIFORNIA, DE MERO CALIFORNIA!
BUT PETE WILSON TAKES ONE LOOK AT ME
AND IT'S BACK TO MEXICO...
Y VOLVER, VOLVER, VOLVER
A TUS BRAZOS OTRA VEZ...

BUT IT WON'T BE THAT EASY, PEDRO WILSON
WE ARE READYING THE BARRICADES
IN LINCOLN HEIGHTS AND IN PICO UNION
THE MASKED COMANDANTES ARE ORGANIZING THE MASSES ON
 COLLEGE CAMPUSES
THEY ARE BROWN THEY ARE BLACK THEY ARE YELLOW
SOME ARE EVEN WHITE GABACHOS DE BUENA ONDA...
THERE ARE CATHOLIC PRIESTS AND EVANGELISTS ON OUR SIDE TOO
READYING THE BATTLE FOR THE SPIRIT OF CALIFORNIA
THEY WILL STAND UP FOR THE WETBACK
SINCE NO DEMOCRAT WILL

133

THEY TELL ME TO GO BACK TO MEXICO
I WOULD GO BACK TO MEXICO
IF THERE WAS A MEXICO TO GO BACK TO
BUT THERE ARE MORE MACDONALDS IN MEXICO THAN MIXTECOS
THERE ARE MORE ROCANROL BANDS THAN MARIACHIS
AND IN THE NORTH THE WHITES TAKE SALSA LESSONS
THE TWENTYSOMETHING HIPSTERS BUY VIRGEN DE GUADALUPE
 T-SHIRTS AT LA LUZ DE JESUS GALLERY ON MELROSE...

YES, PEDRO!
I GUESS WE HAVE INVADED EACH OTHER,
AND NOW THE MOTHER OF ALL BATTLES IS SET TO EXPLODE

YOU KNOW, BROTHERS AND SISTERS,
THEY TOLD ME IN GRADE SCHOOL
THAT WE WERE THE MELTING POT
WE DANCED LA CUCARACHA AND SANG
"MY BONNIE LIES OVER THE OCEAN" TOGETHER
WE WERE TOLD THAT SLAVERY HAPPENED A LONG TIME AGO
THAT IT WAS BAD
BUT THAT AMERICA GOT BETTER
IT DID THE CIVIL RIGHTS THING!

I USED TO BELIEVE, HERMANOS Y HERMANAS!
I USED TO BELIEVE, BROTHERS AND SISTERS!
I ONCE HAD FAITH!

BUT NOW I'M AN EVANGELIST WITHOUT A CREED!
I HAVE NO COUNTRY...
I HAVE NO NAME
I HAVE NO FACE
I HAVE NO GOD...

There's an image that's getting more and more popular in Mexican America these days, one depicting an indigenous Aztec or Maya in full regalia hacking away at a computer keyboard. The first time I saw this was in northern California, hanging on Teatro Campesino founder Luis Valdez's office wall, and most recently on the cover of *Hispanic* magazine. While the image seems steeped in irony, more intriguingly it means that the surviving spirit of Aztlan—as well as those of many indigenous *razas* [races] (Taino, Chibcha, etc.)—is being translated, through the artificial intelligence of binary logic, into the twenty-first century of cyberspace. The sweet tropical fruit of the *mestizaje* [miscegenation] phenomenon of Latin America— once described by Mexican philosopher Jose Vasconcelos as "La Raza Cosmica"—is now "infecting" the Information World, just as said world was taking itself for granted as a suburban oasis in the middle of late capitalism's virtual metropolis.

While the presence of La Raza Cosmica is felt through the efforts of almost every political/academic/advocacy think tank/community organization/university club that has anything to do with Latinos, its most palpable manifestation can be found in the recent "performance art" of Guillermo Gómez-Peña and his collaborator Roberto Sifuentes. The *Temple of Confessions* is a multimedia art project that uses high technology and lowbrow kitsch; it encourages well-intentioned dialogue between different ethnic groups and *razas* as well as exposes some of the trashiest jokes and ethnic slurs found on mid-America's minds.

The central issue in Gómez-Peña and Sifuentes's techno-piracy is access: access by a misinterpreted meta-ethnicity to a re-sanitized American technological infrastructure and access by mainstream America to the

historical and cultural memory of a hybrid *Naftazteca* south-of-the-border being. The following are the words Guillermo used to describe his identity in a 1994 simulacrum of a pirate TV intervention, "Naftazteca," broadcast on cable to over six million homes, and over the M-bone Internet trunk, sponsored by Renassalear Polytechnic Institute:

> I am brown therefore I am underdeveloped
> I wear a mustache therefore I am Mexican
> I gesticulate therefore I am Latino
> I speak about politics therefore I am un-American
> My art is indescribable therefore I am a performance artist

This is not so much a call for help as it is a demand to be heard. The Internet has grown rapidly as a sterile entity only occasionally subverted by extra-textual otherness, a reality underlined by its increasingly corporate skew. Less evident, however, is the way that the Internet is used by cyber-jocks of every stripe to avoid the visceral truth of extra-mainstream cultures. Cyberspace, a place for disembodied voices, can often be used to avoid "identity politics" issues. When a voice is not attached to a face—which suggests ethnicity and race—nor weighted with an accent that suggests a language other than English, it possesses a false, detached purity. While this anonymity can be a liberating force, it is an all too convenient way to ignore the continuing reality of prejudice, and reinforce the monotonal nonregional voice and archetypal American personality which came about with the TV culture of the 1960s.

The goal of Gómez-Peña and Sifuentes's project is to "infect" the Internet with a formidable virus of an alternative culture. Guillermo has redefined the term "infection" in describing

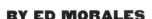

BY ED MORALES

to me some of the intolerant, anti-Other attitudes he has encountered online, making his use of the term ironically appropriate. While Guillermo is a *chilango,* a native of Mexico City, he has in the course of his work transformed himself into a pseudo-Chicano in the aesthetic sense, an enormous cultural accomplishment given the relative estrangement of the Mexican and Mexican-American community. I imagine this process was greatly aided by his years of tutelage in southern "Califaztlan"; the fact is he has greatly absorbed what the scholar Tomas Ybarro-Frausto has defined as "*rasquachismo*": "a sensibility that is not elevated and serious, but playful and elemental. It finds delight and refinement in what many consider banal and projects an alternative aesthetic—a sort of good taste of bad taste."

The end of the century is filled with such thorny contradictions and meta-historical flip-flops of identity, and this is what the *Temple of Confessions* is attempting to document. "Do you think," one of the *Temple's* website pages asks, "that political correctness has gone too far?" "Do you feel that, in the 90s, reverse racism is more of a problem than white racism?" "Do you secretly fantasize about being from a different race or nationality?" The fetishization of the Other in the fantasy life of the mainstream American is an essential element in the psychosexual myth called the American Dream. The advent of high and middle technology has served to make the connection of sex and race even more explicit. The ultraviolet light of racism has been refracted through the lens of media and film into a series of sex crimes. In Riverside, California, a truckful of illegal aliens are attacked by virile white men with sticks; in *From Dusk Till Dawn*—a film by Robert Rodríguez—Mexicans are depicted as oversexualized vampires tempting and tormenting a crew of thrill-seeking Americans.

In their living diorama for the *Temple of Confessions*, Gómez-Peña and his technological co-conspirator Roberto Sifuentes engage in several tableaux of ritual actions: graffiti writing, self-flagellation, making out with a shrunken head, drinking blood from a rubber heart, and *brujeria* [witchcraft] rituals, all used in semiserious, semicomic fashion in glass enclosures. Roaches, middle-kitsch velvet paintings, gang-favored weapons, and the trappings of Santeria are used to evoke the otherness and mystery that thrive in Latino and Mexican cultures. In addition, the two incorporate incoming data from questionnaire responses as well as real-time images that are downloaded by Sifuentes from an FTP site, using CU See Me software. The extra organicness added by the immediate high-tech interaction spins the speaking-in-tongues concept which has always been a staple in Gómez-Peña's performances onto an even dizzier, more manic level.

What Gómez-Peña and Sifuentes have discovered is that Americans are all too willing to disclose this troubling connection between fear and desire in their responses to the *Temple*'s questions. "I want to become a woman. A big, robust, black woman with a ghetto accent," says one respondent. "I fear that Mexican gangmembers will break in one night and rape my grandmother," says another. "I desire more bikini-sweet women on the pages of Low-Rider [sic] magazine and Charo's jiggily body and Rosie Perez's lips around my penis and my semen squirting into her mouth," says yet another. A terrible fear is at the root of these candid admissions, one best articulated by this response to a recent Gómez-Peña and Sifuentes *Temple* show: "I am afraid that (we) will soon be outnumbered citizens." It's no surprise that at one point during this show Gómez-Peña and Sifuentes had an unfortunate encounter with a reactionary racial purity advocacy group of the skinhead variety.

There are uncomfortable questions posed by the reaction Gómez-Peña and Sifuentes provoke through installations like the *Temple of Confessions*. Why are respondents so easily prodded into disclosing exquisitely distasteful perceptions of the Other, while at the same time claiming victimization through "reverse racism?" While the Other has long suffered discomfort for merely manifesting "who they are"—exemplars of a fully developed "foreign" culture which is rich in music, dance, cuisine, and freer sexual expression—the average American seems to be claiming to suffer discomfort at being unable to freely express disdain for the Other and a desire to subjugate them.

Through the use of the *Temple of Confessions*, Gómez-Peña and Sifuentes are excavating an archaeological find of profound significance: tapping into the realm of the subconscious, "San Pocho Aztlaneca" and "El Pre-Columbian Vato" are revealing a primal, archetypal, mythical hostility not unlike the Dennis Hopper character in David Lynch's *Blue Velvet*. Just as the Hopper character screams "Don't you fucking look at me!", allowing the face of ugliness to be concealed, the *Temple of Confessions* becomes a ceremonial space for mainstream America to reflect on its own racism without really being conscious of it.

If the Border between Mexico and the U.S., between monocultural and multicultural consciousness, can be seen as a permeable membrane, then "San Pocho Aztlaneca" and "El Pre-Columbian Vato" are princes of a deadly, yet ultimately healing, disease. Perhaps their role is analogous to that of the Yoruba deity Elegua, the trickster, who casts darkness on the most promising of situations and sheds light on the most negative ones. Without

Above, Ethno-cyborg of a clepto-Mexican gringa. *Opposite*, Cyber-composite of the Mexterminator

a doubt, they have mastered the machines of a many-tongued, apparently unintelligible communicative power by digging deep into the 'hood with the heart of a mariachi singing a mournful song of extinction at Mexico City's Plaza Garibaldi. It's a lot of responsibility to be both the infection and the cure, but as I write this I'm strapping up my arm and searching for a vein for this opiate of horrible truth to enter my body. It's the only way I know I can hold onto what little sanity this society has afforded me.

Temple of Confessions website: http://www.sfgate.com/foundry/pochanostra.html

ROGER BARTRA is an anthropologist, essayist, and author of *The Cage of Melancholy* (Rutgers University Press, 1992), *The Imaginary Networks of Political Power* (Rutgers University Press, 1992), and *Wild Men in the Looking Glass* (Michigan University Press, 1994). His next book *The Artificial Savage* will be published by Michigan University Press in 1996.

PHILIP BROOKMAN is Curator of Photography and Media Arts at The Corcoran Gallery of Art, Washington, D.C. Formerly of the Washington Project for the Arts and Centro Cultural de la Raza, San Diego, his recent projects include *Raised By Wolves: Photographs and Documents by Jim Goldberg,* book and exhibition; *Robert Frank: Moving Out,* exhibition co-curator for the National Gallery of Art; and the exhibition *Farewell to Bosnia: New Photographs by Gilles Peress.* Brookman is also a filmmaker and author of numerous essays about issues of modern photography, media, and visual arts.

ANA CASTILLO is a poet, novelist, and translator. She is the author *The Mixquiahuala Letters* (Doubleday, 1992), *So Far From God* (W.W. Norton & Co., 1993), *My Father Was a Toltec and Selected Poems* (W.W. Norton & Co., 1995), and the recently published *Loverboys* (W.W. Norton & Co., 1996). In addition, her writings have been included in numerous anthologies in the United States and abroad. She has received a National Endowment for the Arts Fellowship and the Carl Sandburg Literary Award in Fiction, among others.

GUILLERMO GOMEZ-PENA is an internationally acclaimed multimedia artist, cultural critic, and author. His performances have been presented nationally at the Franklin Furnace and Exit Art, New York, MOCA, Los Angeles, and the Walker Art Center, Minneapolis; and internationally at La Fundación Joan Miró, Barcelona, The Royal National Theatre, London, and The Convention Center of Vladivostock, in the former Soviet Union. His performances of *Temple of Confessions* and *The Dangerous Border Game* (both with Roberto Sifuentes and currently touring), have received widespread critical acclaim. He has received the Prix de la Parole and a MacArthur Foundation Fellowship, among others. Gómez-Peña is the author of *Warrior for Gringostroika* (Graywolf Press, 1993) and *New World Border* (City Lights Books, 1996). Gómez-Peña was born in Mexico City and came to the United States in 1978.

JUAN FELIPE HERRERA is a poet, professor, and author of *Exiles of Desire* (Arte Publico Press, University of Houston, 1985), *Night Train to Tuxtla: New Stories and Poems* (University of Arizona, 1994), and *Love After the Riots* (Curbstone Press, 1996). His next book *Mayan Drifter: Chicano Poet in the Lowlands of America* will be published by Temple University Press in 1997. He has been awarded several grants and fellowships, including a National Endowment for the Arts Fellowship and a Lila-Wallace · National Touring Fellowship.

NANCY JONES has been a museum educator at the Detroit Institute of Arts since 1984. She confesses a profound belief in the transformative power of art and a commitment to the potential of museums as sites for discourse about contemporary cultural and social issues. In Fall 1994, she organized the *Temple of Confessions* in Detroit, and treasures the experience of conspiring with Gómez-Peña and Sifuentes.

RUBEN MARTINEZ is an award-winning journalist, poet, and performer, who has appeared at such venues as the Los Angeles County Museum of Art, the Whitney Museum of American Art, New York, and

X-Teresa Alternative Art Space, Mexico City, among others. His work has been published in *The New York Times, The Los Angeles Times, The Village Voice,* and *La Opinión.* Martínez is the author of the critically-acclaimed book *The Other Side: Notes from the New L.A., Mexico City and Beyond* (Vintage, 1993). He currently resides in Mexico City where he is working on his second book about the changing cultural and political landscape of Mexico for Metropolitan/Holt.

ED MORALES is a staff writer for *The Village Voice.* He is also contributing editor to *Sí* magazine, and has written for *American Theatre, Vibe, Entertainment Weekly, Rolling Stone,* and *Details.* Morales has appeared nationally as a member of the Nuyorican Poets Cafe live spoken word tour, and his short fiction has appeared in *Iguana Dreams* (HarperCollins, 1992), and *Boricuas* (Ballantine, 1995). He lives in New York.

ROBERTO SIFUENTES is an interdisciplinary artist from Los Angeles now living in New York. A graduate of Trinity College, Hartford, Connecticut, he has toured with Guillermo Gómez-Peña in performances, lectures, and installation projects throughout the United States, Europe, and Latin America. Additional collaborations include *Borderama* and *Naftazteca: Cyber-Aztec TV for 2000 AD,* an interactive performance art television special broadcast to over six million homes.

ADDITIONAL CAPTIONS/CREDITS pp. 9, 46, 103: Installation of the *Temple of Confessions* at the Scottsdale Center for the Arts, 1994, © Tania M. Frontera; pp. 13, 28: Installation of *Temple of Confessions* at Ex-Teresa Arte Alternativo, Mexico City, 1995, © Martin Vargas; pp. 16-17: Installation of the *Temple of Confessions* at the Detroit Institute of Arts, 1994, © Dirk Bakker; p. 20: Catholic prayer card; pp. 24-25, 27, 59, 108: *Temple of Confessions* at Ex-Teresa Arte Alternativo, © Monica Naranjo; p. 26: "Ancestor of San Pocho Aztlaneca"; p. 30, top: Norma Medina as a nun, © Kay Young; p. 30, bottom: Michelle Ceballos as a nun, © Robert Guignard; p. 31: Carmel Kooros as a belly dancer/nun, © Eugenio Castro; pp. 34-40: "End-of-the-Century Saints/Conceptual Velvet Art"—concept by Guillermo Gómez-Peña, realization and traditional velvet painting by Jorge T.— "El Aztec de East L.A." (p. 34), "La TJ Guera" (p. 35, top), "La Pinta" (p. 35, bottom), "La Neo-Primitiva" (p. 36), "Saint Frida of Detroit" (p. 37), "El Transvestite Pachuco" (p. 38), "La Yuppie Bullfighter" (p. 39), "El Warrior for Gringostroika" (p. 40); p. 45: Carmel Kooros and Guillermo Gómez-Peña, © Eugenio Castro; p. 48: "Norma Lee," photograph by Jesus Carlos, courtesy of *La Pusmoderna* magazine; p. 63: Letter of complaint to the Chairman of the Scottsdale Center for the Arts; pp. 66-67: Border postcards, courtesy Sal García; pp. 75, 77: Mexican evangelist comic book; pp. 80-81: Old British engraving found at a London used bookstore; p. 84: Postcard from France; p. 85: Postcard from Eastern Europe; p. 89: "Exoticized image of a generic third world woman," © Vintage Images; p. 100: "Superbarrio Gomez" courtesy Archive Photos; p. 107: Photograph by Roberto Espinosa; p. 111: Poster found at a Montana roadside museum; pp. 112-113, 116, 117: Street intervention, Detroit, 1994, © Kay Young; pp. 114-15: Street intervention, Pittsburgh, 1994, © Nancy Jones; pp. 118-119, 124, 125: *The Cruci-Fiction Project,* Rodeo Beach, Marine Headlands, Sausalito, California, 1994, © Neph Navas; pp. 121, 134: Images by Leon Ferreri, Brazil/Argentina; p. 122: Photograph presented as an offering at the performance of the *Temple* at the Detroit Institute of Arts; pp. 126-27: *The Cruci-Fiction Project,* © Annica Karlsson Rixon; p. 129: Mexican police officer during a mock crucifixion to protest poor wages and corruption in the Mexico City police department, October 14, 1995, AP/Wide World Photos; p. 131: Diorama of the holy blind child "*las Capuchinas*" at a Mexican Catholic church; p. 137: Roberto Sifuentes as "El Cybervato" © Eugenio Castro; pp. 140, 141: Computer-generated images © David Kimura; Back cover endpapers: left, Guillermo Gómez-Peña as "El Mexterminator" © Monica Naranjo; right, Roberto Sifuentes as "El Cybervato" © Wolfgang Kirchner.

TEMPLE OF CONFESSIONS
MEXICAN BEASTS AND LIVING SANTOS

"The Temple as a Mirror" © 1996 Philip Brookman
"The Temple in Detroit" © 1996 Nancy Jones
"Mexican Beasts and Living Santos," "Rito/Blood Rituals," and "The Cruci-Fiction Project" © 1996 Guillermo Gómez-Peña
"Interview with Roberto Sifuentes" © 1996 Marco Vinicio Gonzalez
"Ode to Rosa López/Oda a Rosa López," "City Poem #5," and "Scripture 187:95" © 1996 Rubén Martínez
"Artificial Savage" © 1996 Roger Bartra
"Subtitles," from *Loverboys* by Ana Castillo © 1996 Ana Castillo;
reprinted by permission of W. W. Norton & Company, Inc., courtesy of Susan Bergholz Literary Services, New York.
"Superbarrio Announces White House Bid," March 20, 1996, reprinted by permission of Reuters.
"187 Reasons Why Mexicanos Can't Cross the Border: An Emergency Performance Poem" © 1996 Juan Felipe Herrera
"Los Techno-Subversivos: The End of False Purity in Cyberspace" © 1996 Ed Morales
"Easy Spanish for Construction" © 1991 Mitchell Brothers Press; reprinted by permission.
"Easy Spanish for Lawn & Garden" © 1993 Mitchell Brothers Press; reprinted by permission.
Compilation © 1996 powerHouse Cultural Entertainment, Inc.

Published in the United States by powerHouse Books

powerHouse Books is a division of powerHouse Cultural Entertainment, Inc.
180 Varick Street, Suite 1302
New York, New York 10014-4606
telephone 212-604-9074, fax 212-366-5247

First edition, 1996

Library of Congress Cataloguing-in-Publication Data:

Gómez-Peña, Guillermo.
 Temple of confessions : Mexican beasts and living santos / by
Guillermo Gómez-Peña and Roberto Sifuentes ; with texts by Philip
Brookman . . . [et al.]. — 1st ed.
 p. cm.
 ISBN 1-57687-004-9 (hdc)
 1. Gómez-Peña, Guillermo. Temple of confessions. 2. Performance
art—United States. 3. Artistic collaboration—United States.
I. Sifuentes, Roberto, 1967- II. Brookman, Philip. III. Title.
NX512.G66A78 1996
709'.2—dc20
 96-30577
 CIP

ISBN 1-57687-004-9

Distribution in the United States and Canada by D.A.P./Distributed Art Publishers
toll free 1-800-338-BOOK, fax 908-363-0338

10 9 8 7 6 5 4 3 2 1

Printed in Hong Kong

A limited edition of *Temple of Confesssions* is available upon inquiry;
please contact the publisher.
(Limited Edition ISBN 1-57687-006-5)

The exhibit and performance of the *Temple of Confessions*
will take place in 1996 at The Corcoran Gallery of Art, Washington, D.C.,
October 12 through December 30.

BOOK DESIGN BY FRANCESCA RICHER

COMING SOON

EL MEXTERMINATOR